Images of Modern America

ITALIANS OF LACKAWANNA COUNTY

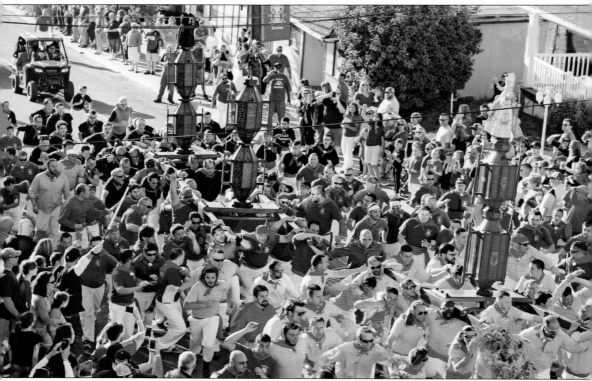

Lackawanna County, Pennsylvania, boasts one of the largest Italian American populations in the United States. One of the county's largest celebrations of Italian American heritage and culture is "La Corsa dei Ceri," or the Race of the Saints, held every May in Jessup. La Corsa dei Ceri was brought to Jessup by immigrants from Gubbio, Italy, whose patron saint is St. Ubaldo. (Courtesy of Linda Bonacci Anelli.)

FRONT COVER: The Family of St. George participates in "La Corsa dei Ceri," or the Race of the Saints, in Jessup. St. George is said to represent Gubbio's tradesmen and merchants. (Courtesy of Linda Bonacci Anelli)

UPPER BACK COVER: For more than 90 years, the Italian community of Carbondale has celebrated the Feast of Our Lady of Mount Carmel in mid-July. A statue of Our Lady of Mount Carmel is carried through the streets of Carbondale and residents can pin monetary offerings to her sash as she goes by. (Courtesy of Nancy K. Free.)

LOWER BACK COVER: (left) The procession in honor of St. Rocco is held every August in Dunmore's Bunker Hill section. For more than 100 years, it has taken place on the last day of a three-day festival in honor of the saint. The men of the parish carry statues of St. Rocco, the Blessed Virgin Mary, St. Joseph, and St. Anthony over a 1.5-mile trail. (Author's collection.) (center) Lackawanna County is home to "La Festa Italiana," the largest Italian American festival in the region. Held annually over Labor Day weekend on Courthouse Square in Scranton, the festival was extended to four days in 2016 to include First Friday Scranton. (Courtesy of Michael Taluto.) (right) Many pizzerias in the region make their trays in the "Old Forge style," as Old Forge, Lackawanna County, is considered the "Pizza Capital of the World." *USA Today* ranked its pizza no. 1 in the United States and even pizza makers in Naples, Italy, refer to rectangular pizza as "Old Forge style." (Author's collection.)

Images of Modern America

ITALIANS OF LACKAWANNA COUNTY

Stephanie Longo

ARCADIA
PUBLISHING

Published by Arcadia Publishing
Charleston, South Carolina

Printed in the United States of America

Library of Congress Control Number: 2016953987

For all general information, please contact Arcadia Publishing:
Telephone 843-853-2070
Fax 843-853-0044
E-mail sales@arcadiapublishing.com
For customer service and orders:
Toll-Free 1-888-313-2665

Visit us on the Internet at www.arcadiapublishing.com

This book is dedicated to my great-grandparents, Salvatore and Nicoletta Castellano Luongo and Salvatore and Francesca La Scala Mascaro. They chose to pursue their American dreams in Lackawanna County and for that I will always be grateful.

CONTENTS

ACKNOWLEDGMENTS

Sometimes, no matter how much you want to give a project your all, something happens along the way to throw you off course. I was genuinely worried that this book would never see the light of day, as while writing it, my life took several unexpected turns. I have learned that when faced with adversity, you have to keep a positive attitude and move forward because the end goal, in this case that of telling the story of Lackawanna County's modern Italian American community, was more important than anything else.

While writing can often be a solitary task, I have been blessed to have some amazing people in my life cheering me on. To the entire community of Jessup, I wish to extend the most heartfelt thanks—your community's dedication to preserving your heritage is contagious and I am most proud to call you my friends. I'd also like to thank the Lackawanna County Library System for all of the help staff gave me with putting the word out about this project. To Greg Scandale, thank you for your enthusiasm for anything having to do with our region's Italian heritage. To all of my friends who loved and supported me along the way, a simple thank-you just doesn't seem enough; just know that I love and respect you all, always.

To everyone at Arcadia Publishing, especially my title manager, Angel Hisnanick, thank you for always believing in this project and for being so accommodating with schedules and deadlines.

To my mother, Ann Marie "Annie" Longo, thank you for instilling in me a strong sense of pride in our family's heritage. It is because of that day when I was five years old and you took my hand to trace the outline of Italy on the map, telling me that my Nonno Joe came from there, that I ended up dedicating my life to preserving Italian American heritage. Thank you for teaching me that no matter what someone says about you or believes about you, true character always shines through.

And to the Italians of Lackawanna County, past, present, and future, *grazie di cuore* for allowing me to once again tell your story.

INTRODUCTION

Ad ogni uccello, il proprio nido è il più bello.
(There's no place like home. Literal translation: "Every bird
feels that its nest is the most beautiful of all.")

There is no mistake about it, the Italian spirit is evident throughout Lackawanna County. In 2015, the United States Census Bureau released its annual American Community Survey, which includes a list of the top 20 "most Italian" cities and towns in the nation. Of the five Pennsylvania municipalities on the top 20 list, two are from Lackawanna County, while the remaining three are from neighboring Luzerne County, proving that northeastern Pennsylvania is truly the heartbeat of the commonwealth's Italian heritage. In Lackawanna County, the Borough of Dunmore is no. 12 on the list, with 38.9 percent of its residents claiming Italian ancestry, while the Borough of Old Forge, also known as the "Pizza Capital of the World," is no. 17 on the list, with 37.8 percent Italian American residents.

Italian Americans are the largest ethnic group overall in Lackawanna County, clocking in at 20.1 percent of residents, according the Census Bureau. With such a large and strong Italian American population in an era where younger generations may or may not be tied to their respective ethnic heritages, it stands to reason that the residents of Lackawanna County should be praised for the lengths they go to in maintaining their ties to their ancestral homelands.

Anyone who has visited Lackawanna County can attest that it is a patchwork of ethnicities: Its county seat, the city of Scranton, boasts one of the largest St. Patrick's Day parades in the nation and is also the seat of the Polish National Catholic Church. Scranton is also the sister city of three towns in Italy—Caronia, Guardia dei Lombardi, and Perugia. The remainder of the county is filled with additional enclaves of Eastern European, Irish, Welsh, and other ethnic groups. With a new wave of immigration to the region, Lackawanna County is also witnessing an influx of newcomers from Africa, Asia, and Central and South America.

The beauty of living in Lackawanna County is that anyone, regardless of his or her original ethnic ancestry, can embrace the traditions of the various original immigrant groups who came to the area to work in the coal mines or on the railroads that it is known for. The same sentiment goes for the new ethnic groups who are bringing their traditions and cuisine to our region, adding to the vibrancy of daily life.

The Italian ethnicity permeates daily life in our region—Italian cuisine has become a part of the family's weekly dinner menu, with Friday nights known as "pizza night" throughout northeastern Pennsylvania and each municipality having a wide variety of pizzerias, all with their own special twists on the classic dish. A family might do their grocery shopping at Dunmore's Riccardo's Market and run across the street to DePietro's Pharmacy to pick up prescription medicine. Or someone on a lunch break might run to either Catalano's in Scranton's West Side or Doma's in Dunmore to pick up a ready-made Italian hoagie on fresh bread with either hot or sweet peppers

and only the finest lunchmeats and cheeses available. To end the workday, someone might open up a bottle of wine from one of the region's wide variety of wineries. To say that the average citizen of Lackawanna County has some daily contact with Italian American heritage and history would be an understatement.

In terms of events, thousands of people of all ethnic backgrounds flock to Jessup each May for "La Corsa dei Ceri," or the Race of the Saints, as well as to "La Festa Italiana," which is held every Labor Day weekend, proving that you don't have to be Italian American to enjoy an Italian-themed event. These festivals, among others, are a testament of a profound spirit of community where everyone is welcome throughout Lackawanna County, no matter his or her race, color, sexual orientation, ethnic background, or creed.

Italians of Lackawanna County is just one more representation of a continuing lifelong love for my ethnic heritage and a desire to celebrate my *compaesani* in this region. In ethnic studies, so much attention is given to the stories of immigrants when they left their homelands but little is heard of their lives once they stepped off Ellis Island. Even less attention is given to the second, third, and fourth generations, who may consider themselves Americans through and through but who also share a profound love for their ancestral homelands. The aim of this book is to show what is happening today in Lackawanna County—how the Italian American heritage is lived and how it permeates all aspects of daily life in the region. Because of the largeness of our Italian American population, this book is by no means a complete history—to do so would require several volumes—but rather a sampling of what the Italians of Lackawanna County stand for and a glimpse of what takes place here every day.

In my first book, *Italians of Northeastern Pennsylvania*, I close my introduction with an Italian proverb—"Se semini e curi, tutto dura," or "If you take care of what has been planted, it will last." I believe that the Italians of Lackawanna County have done exemplary work in taking care of what was planted in them through their ancestors and I believe this work will continue. I also hope this work inspires the other ethnic groups in our county to record their history, past and present, so future generations will always remember that our traditions have molded who we are and who we will become as a society.

To anyone who reads this book, *grazie!*

One

A STRONG FOUNDATION

Un buon seme dà buoni frutti
(A strong foundation yields strong results. Literal translation: "A good seed gives good fruit.")

To tell the story of the Italians of Lackawanna County, one must begin with the people. When the first wave of Italian immigrants arrived in Lackawanna County from regions such as Umbria, Campania, Calabria, and Sicily, they had to work a variety of jobs, such as farmers and skilled laborers. However, the chief employer for Italian immigrants arriving in Lackawanna County was the anthracite coal mining industry. Working conditions in the coal mines were far from ideal, and miners could spend 12 or more hours underground at the risk of losing a limb or even their lives.

The immigrants knew that risking their lives was a small price to pay for the security of their families. A loss of even a day's worth of wages put them at the mercy of a system that was far from welcoming. The newly arrived Italian immigrants spoke a different language and observed customs that appeared strange to the Northern and Western European population (mainly Welsh, Irish, and German) that had put down roots in the region a generation before their arrival. Italians often found themselves subject to discrimination, partly due to perceived ties to the Mafia and the Black Hand. They had to do whatever they could to ensure their family's survival in the New World.

It was this work ethic that the first generation of Italian Americans tried to instill in their children, who then passed it down to their own children. That strong foundation helped pave the way for many of Lackawanna County's most notable residents—people who have excelled in the fields of the arts, medicine, education, and finance, among others. These people have become leaders in the community and have carried on their family's pride in their ethnicity by creating various Italian American associations, societies, and organizations.

"A strong foundation yields strong results," and for the Italians of Lackawanna County, the survival of their families was the strongest result imaginable.

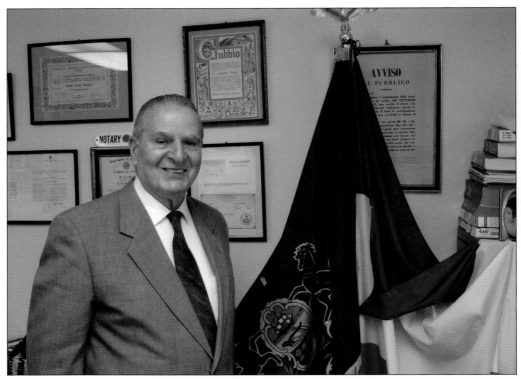

Northeastern Pennsylvania holds a special distinction with the Italian government as it is the site of an honorary consulate of the Republic of Italy. First held by Fortunato Tiscar, the position of honorary consul has been held by Francesco Stoppini since 1993. A native of Assisi, Italy, Stoppini and his wife, Mary Ann, own American Group Travel in Elmhurst. (Author's collection.)

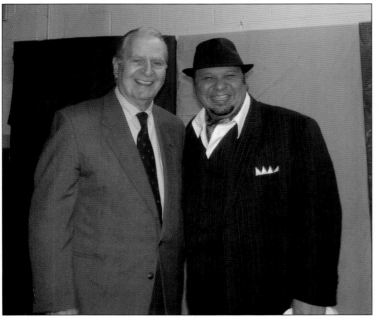

Francesco Stoppini regularly participates in Italian American–themed events throughout Lackawanna County, as well as in neighboring areas. In this photograph, Stoppini welcomes accomplished Italian American musician Michéal Castaldo to Clarks Summit for a benefit event celebrating Italian American heritage and culture. (Author's collection.)

A native of Calabria, Michéal Castaldo is a regular visitor to Lackawanna County. In addition to his musical career, he imports his family's high-quality extra virgin olive oil and balsamic vinegar to the United States. He also rents his refurbished childhood home, Villetta Mimma Vittoria, to vacationers in the region of Calabria. A passionate ambassador of his heritage, Castaldo regularly seeks innovative ways to preserve and promote Italian American culture. (Courtesy of Michéal Castaldo)

While not a native of Lackawanna County, best-selling Italian American author Adriana Trigiani spent considerable time in the region as her family hails from Roseto, Northampton County. Trigiani's best friend, Michael Patrick King, was born and raised in Scranton. She was also close friends with the late Joe O'Brien of Scranton, who did voice-over work for her books and who was in the television series *City Kids*, for which Trigiani was writer and executive producer. "Scranton means family to me!" she said. (Courtesy of Adriana Trigiani.)

Valley View School District, located in Archbald and serving the boroughs of Archbald, Blakely, and Jessup, is the only school district in Lackawanna County to offer Italian as a language elective. This is because of the extremely close ties between Jessup and its sister city Gubbio, Italy. (Courtesy of Valley View School District.)

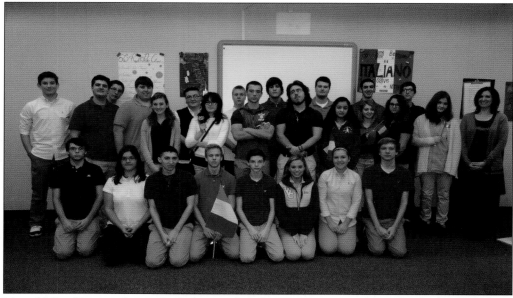

Many Valley View students take Italian so that they can communicate with relatives in Italy, as well as further their studies as part of various high school and college foreign study programs. (Courtesy of Valley View School District.)

The Lackawanna County Library System regularly promotes Italian American heritage events throughout all nine of its branches. One very noteworthy event took place in 2013 when the Abington Community Library, located in Clarks Summit, welcomed retired vice consul of Italy in Philadelphia Renzo Oliva (right) and his wife, Juri Kim (left). Both Oliva and Kim are visual artists and displayed their work in the Abington Community Library, culminating in a community welcome celebration. Also pictured is Leah Ducato Rudolph. (Courtesy of the Abington Community Library.)

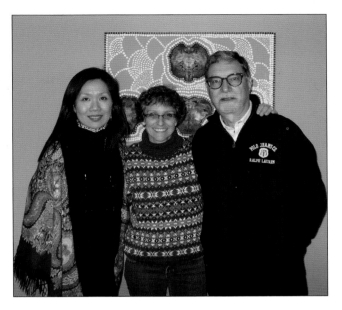

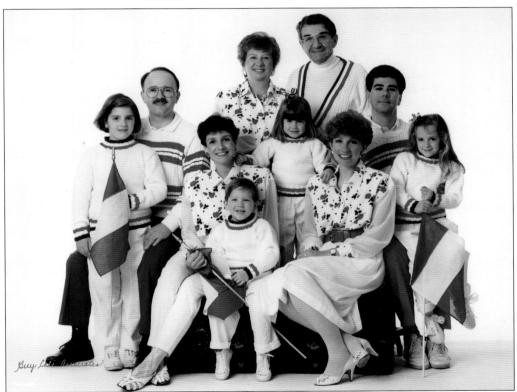

Leah Ducato Rudolph served as the director of the Abington Community Library from 2005 to 2017. This family photograph from the 1980s celebrates her family's pride in their Italian heritage. Rudolph's family claims origins from Sicily and Calabria, while her husband Ken's family clams origins from Liguria and Tuscany. (Courtesy of Leah Ducato Rudolph.)

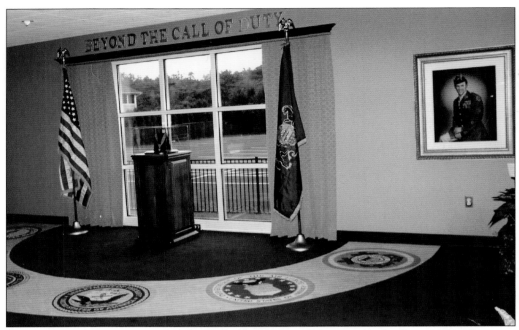

The Gino Merli Room opened at the Valley Community Library in Peckville in 2004. The room was named in honor of the late Merli, who earned the Medal of Honor in 1945 for his bravery at Sars-la-Bruyère, Belgium, by faking his death several times to defend against the Germans. He later learned that the American forces had succeeded in their counteroffensive and that the Germans had asked for a truce. (Courtesy of the Valley Community Library.)

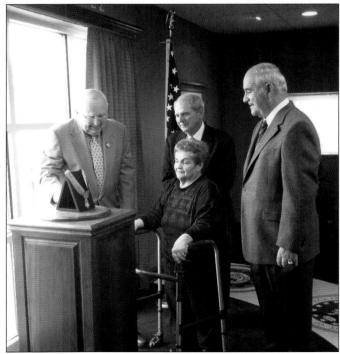

Gino Merli's wife, Mary Lemoncelli Merli, presented the Medal of Honor, as well as other mementoes from her husband's life, to the Valley Community Library as a permanent memorial to him. Gino Merli said of receiving the Medal of Honor, "We all did what we had to do back then. I didn't, as the media would say, 'win' the Medal of Honor. I was not out winning anything. Like anyone else, I was doing my duty and preserving my life." (Courtesy of the Valley Community Library.)

Today, the Gino Merli Room is used as the hub of life at the Valley Community Library, hosting meetings and events as well as book discussions and presentations. Various images from Merli's life grace the walls of the room, including this photograph of him with Bob Hope (left). (Courtesy of the Valley Community Library.)

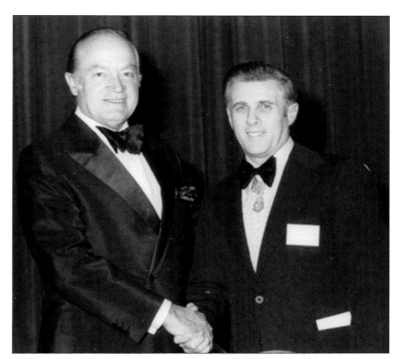

Merli's legacy is seen throughout Lackawanna County. The street he lived on in Peckville is now known as Gino Merli Drive and the former Northeastern Veterans' Center was renamed as the Gino J. Merli Veterans' Center in 2002. The Merli Center is located on Mulberry Street in downtown Scranton on the site of the former Scranton State General Hospital. (Courtesy of the Gino J. Merli Veterans' Center.)

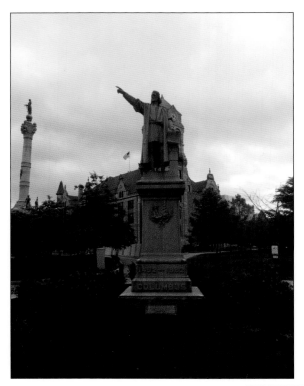

The Christopher Columbus statue on Scranton's Courthouse Square was unveiled during the city's first Columbus Day celebration on October 21, 1892. The statue was sculpted by the event's master of ceremonies, Frank Carlucci, who was responsible for the creation of the Ellis Island Landing Station in New York Harbor and the Grand Stairway at Arlington National Cemetery. Legend states that his front yard in Scranton served as the studio for the creation of the Columbus statue. (Author's collection.)

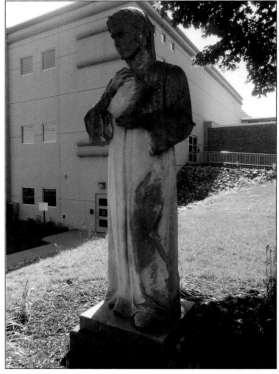

Designed by Augustino Russo and originally dedicated in 1923 as a gift to the City of Scranton by its Italian American population, this statue of the great Italian poet Dante was moved to the campus of the University of Scranton in 1966. The dedication ceremony on July 28, 1923, drew several thousand people and featured remarks from Fortunato Tiscar, the first Italian consular agent in the region; Scranton mayor John Durkan; and Michael J. Hoban, bishop of the Diocese of Scranton. (Author's collection.)

St. Lucy's Parish, located in Scranton's West Side, was the first Italian parish in Lackawanna County, established in 1891 by the Reverend Rosario Naco. The current church was completed in 1928. The church originally had a bell tower and a marble pulpit, but both were removed in 1956. The principal architect of St. Lucy's was Vincent Russoniello. (Author's collection.)

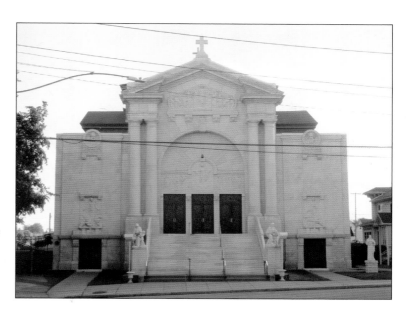

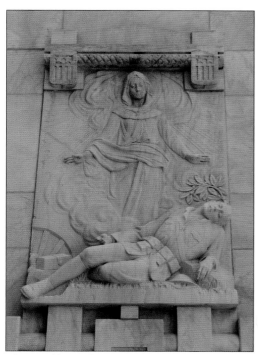 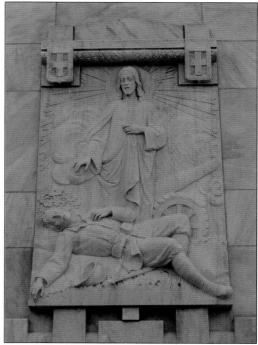

The marble work at St. Lucy's was done by Augustino Russo, who had a workshop in Pietrasanta, Italy, where the sign read "A.N. Russo: The Scrantonian Sculptor." Russo's visible work at St. Lucy's includes the marble front and a marble staircase that were both carved in Pietrasanta. Pictured on the facade of St. Lucy's are Russo's sculptures of a dying American soldier with the Virgin Mary (left) and a dying Italian soldier with Jesus (right) during World War I. (Author's collection.)

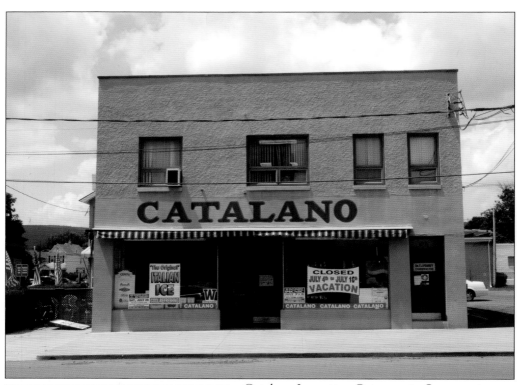

Catalano Importing Company in Scranton is a staple in the community, as owner Paul Catalano has been at the business's helm for more than 50 years. His father started the company more than 90 years ago. Known for its Italian specialties, deli, gelateria, and hard-to-find imports, Catalano's has been recognized nationally as a destination for Italian Americans looking to keep their families' culinary traditions alive. (Author's collection.)

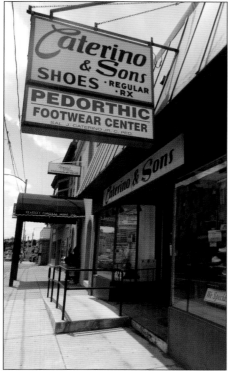

Following in the tradition of Italian shoemakers, Caterino and Sons Shoes was opened in 1920 in Scranton's West Side. The business specializes in orthopedic shoes and caters to people with special footwear needs. (Author's collection.)

Founded in 1935, Dunmore-based Doma Importing Company is an authentic Italian market that specializes in producing homemade mozzarella cheese, as well as various sausages. The store also offers more than 75 different cuts of pasta, in addition to a wide variety of traditional sweets, holiday items, and Italian handicrafts. (Author's collection.)

The history of Dunmore's Riccardo's Market begins in the early 1900s when Salvatore Riccardo arrived in the United States from Naples, Italy, and began peddling produce in New York City from a horse-drawn cart. He moved to Scranton and opened an outdoor produce stand. Now in its fourth generation, Riccardo's Market has been located on Wheeler Avenue as well as on Blakely Street. Rocco Riccardo opened a new, expanded Riccardo's Market on Wheeler Avenue, across from its original location, in 2010. (Author's collection.)

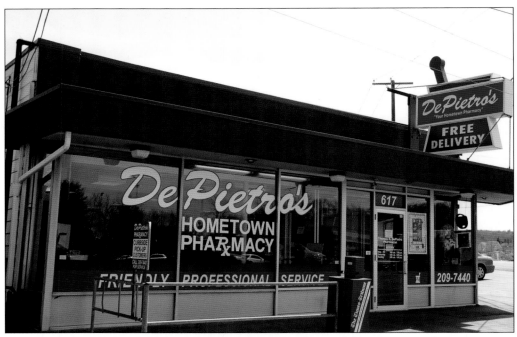

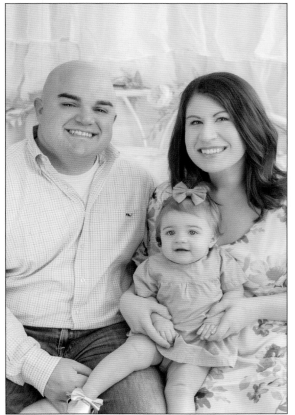

Located directly across the street from Riccardo's Market, DePietro's Pharmacy opened in 2012. Run by Dunmore native Tom DePietro, the pharmacy places a heavy emphasis on individualized customer care, as well as providing hard-to-find medications to patients throughout Lackawanna County. (Courtesy of the DePietro family.)

The DePietro family is heavily active in local charitable causes and events. Eugenia DePietro is also a photographer in the Dunmore area. Both she and her husband, Tom, feel that a commitment to the community is essential in running a business. Here, they are pictured with their daughter, Dominica. (Courtesy of the DePietro family.)

Sal Maiolatesi Jr. opened the Maiolatesi Wine Cellars in 1999. He learned the trade of winemaking when he and his father discovered an old wine press in the basement of his grandmother's home. Sal learned that his great-grandfather made the press years ago and decided to pick it up as a hobby. By 2003, the Maiolatesi Wine Cellars had become so successful that Sal decided to focus on winemaking full-time. (Courtesy of Maiolatesi Wine Cellars.)

Maiolatesi Wine Cellars now sells more than 30 varieties of wine, but the staple varieties include Mia Labruscana, Mia Rosé, and Mia Bianco—all inspired by Sal Maiolatesi's firstborn daughter, Mia. The winery's reserve wines are Giulia's Reserve Merlot, Giulia's Reserve Cabernet Sauvignon, and Giulia's Reserve Chardonnay—all inspired by his second daughter, Giulia. (Courtesy of Maiolatesi Wine Cellars.)

The original Maiolatesi Wine Cellars was located in Childs, but was destroyed by a fire in 2007. The new 10,000-square-foot Maiolatesi Wine Cellars in Scott Township opened in March 2009. The Tuscan-themed building boasts a state-of-the-art winemaking facility as well as a tasting room. One of the main features of the new location is this handmade cherrywood wine bar handcrafted by Sal's father, Sal Maiolatesi Sr. (Courtesy of Maiolatesi Wine Cellars.)

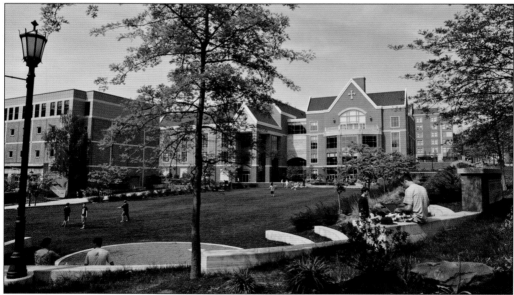

The Patrick and Margaret DeNaples Center at the University of Scranton opened in 2008. Located along Mulberry Street, the building was named in honor of the parents of the DeNaples family, known throughout Lackawanna County for its various philanthropic efforts. The building houses dining facilities, a Student Forum, the Ann and Leo Moskovitz Theater, and other university offices. The building replaces the Gunster Memorial Student Center, which was razed for the project. (Courtesy of the University of Scranton.)

The Parise family has been in the funeral business since 1941. Parise Funeral Homes was founded by Carmine J. Parise, who learned the trade from his uncle Jacob B. Graziano, the first funeral director of Italian decent to serve the growing Italian immigrant population in Carbondale during the early part of the 20th century. Parise Funeral Homes now operates from three locations in Lackawanna and Susquehanna Counties. (Courtesy of the Parise family.)

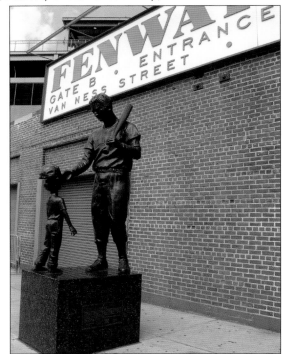

The Parise family claims origin from the town of Celico in the province of Cosenza in the region of Calabria. The family regularly participates in the creation of monuments in Lackawanna County, as well as nationwide, including the Ted Williams memorial at Fenway Park in Boston. (Courtesy of the Parise family.)

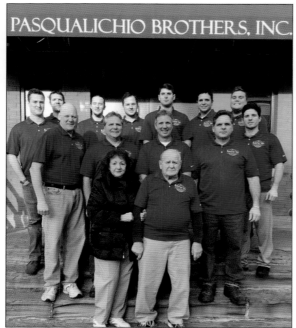

Pasqualichio Brothers was established in 1980 by four brothers and began as a wholesale distribution company specializing in the sale of fresh pork, poultry, and beef to supermarkets in eastern Pennsylvania, New York, and New Jersey, as well as small stores and restaurants throughout Lackawanna County. Now in its second generation, Pasqualichio Brothers also produces Butcher Van Gourmet meat products, which are sold on a national basis in club stores, supermarkets, specialty retailers, and grocery chains. (Courtesy of the Pasqualichio family.)

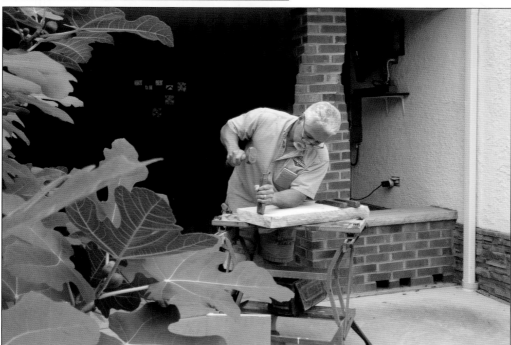

Tony Amico of Throop is known throughout the region for his stonemasonry and is also an artist. His works can be seen at many homes and businesses throughout Lackawanna County and beyond. Amico credits his art teacher at Dunmore High School, Jane Brier, as his greatest influence. In this picture, he is carving stone in the shade of a fig tree his grandfather planted when he arrived in the United States from Sicily. (Courtesy of Tony Amico.)

Daniel J. Santaniello has been the
president and chief executive officer
of Fidelity Deposit and Discount Bank
since December 2000. Born and raised
in Lackawanna County, he is a 1990
graduate of Marywood University, where
he earned his bachelor of science degree in
accounting. His family originally hails from
the town of Santa Maria Infante, Campania.
(Courtesy of Daniel J. Santaniello.)

Clarks Summit resident and
Philadelphia native Paola
Giangiacomo is known locally for
her nearly 13-year stint at WNEP-
TV. An award-winning journalist,
she can now be heard anchoring
news from New York City on Fox
News Headlines 24/7 on SiriusXM
Channel 115, and she can seen as the
host of the award-winning medical
series *Call the Doctor*, on WVIA-TV.
(Courtesy of Paola Giangiacomo.)

What is now known as Sarno and Son began in 1940 as Sarno's Custom Tailor Shop by Ralph Sarno, who immigrated to the United States from Italy. Focusing on custom suit making united with genuine customer care, the business soon began to grow and include alterations, dry cleaning, and tuxedo rentals. Now in its third generation, the business is currently run by Ralph's children, Mark and Nancy. Sarno and Son now has a presence in 13 states and the District of Columbia. (Courtesy of Nancy Sarno de los Rios.)

Scranton resident Ernest Giordano, born in Guardia dei Lombardi, Italy, was inducted into the International Association of Clothing Designers in 1970. He worked for 35 years as head designer, vice president of manufacturing, and general manager of U.S.I. Apparel. In 1996, with his son and two other partners, Giordano began International Fashions Company, where he served as president and chief executive officer until his retirement in 2012. (Courtesy of Ernest Giordano.)

For more than 50 years, the Poets have been synonymous with music in Lackawanna County and beyond. Currently comprised of (clockwise from upper left) John Hollenbaugh, Toby Naro, Alan Shields, Pat Luongo, Frankie Gervasi, and Nick Luongo, the band has gone through many personnel changes since its beginnings as the Dimensions. Legend has it that the band formally began in July 1963 when Frankie Gervasi met Pat Luongo on Ash Street. Frankie asked Pat if he wanted to play a gig with him, Dominick Netti, and Phil Rossi in Scranton. Pat was 12 years old at the time; Frankie was 15. (Courtesy of the Poets.)

The Poets disbanded briefly during the late 1960s and early 1970s when several members joined the military. Reuniting in 1972, the group quickly became the most popular band in the region, setting attendance records locally and opening for national acts such as the Four Seasons, Tina Turner, and Neil Sedaka. At the end of 1973, the Poets recorded their first album, *Frankie and the Corvettes*. (Courtesy of the Poets.)

Continuing to perform to this day, the Poets are the featured act at a wide variety of festivals throughout northeastern Pennsylvania and beyond. Performing a variety of hits from the 1950s and 1960s—including tributes to Elvis, Neil Diamond, the Beatles, the Four Seasons, the Beach Boys, and Johnny Cash—the Poets have also performed on Royal Caribbean cruise ships. (Courtesy of the Poets.)

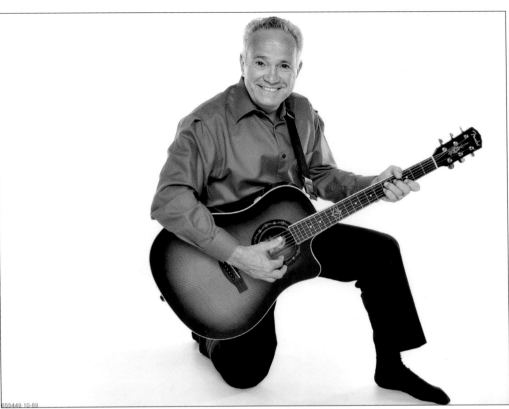

655449 10-89

Founding member of the Poets Frankie Gervasi also performs as a solo act. Known as "Northeastern Pennsylvania's Oldest Teenager," he has dedicated himself full-time to his music career and also works as a freelance audio/video contractor. A proud Italian American, Gervasi has also been honored by a variety of local, regional, and national Italian American organizations. (Courtesy of Frankie Gervasi.)

Brothers Nick and Pat Luongo were also founding members of the Poets and have performed as the Luongo Brothers Band since 2013. Nick (right) and Pat (left) have played professionally since they were ages 14 and 10 respectively. The Luongo Brothers Band expands upon the Poets' repertoire by adding hits from the 1970s and 1980s to its playlist. (Courtesy of Nick Luongo.)

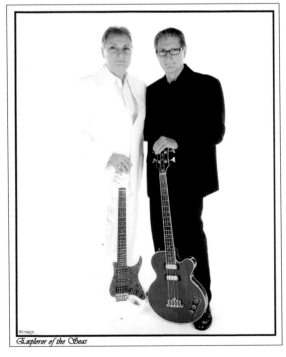

©Image

Explorer of the Seas

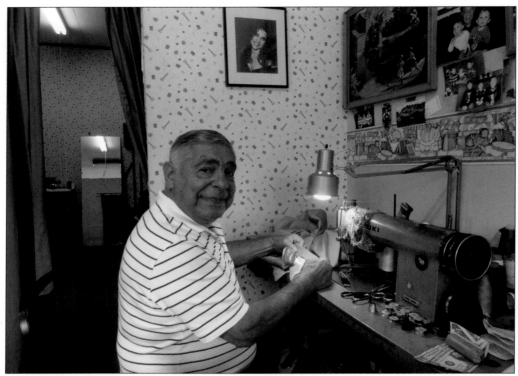

Domenick Mangiola established Domenick's Expert Tailoring in Scranton's Green Ridge section in 1975. He arrived in the United States from Reggio Calabria in 1962 and has worked as a tailor since he was six years old, having learned the craft from his father. Domenick's clientele stretches as far as New York City and Philadelphia and he even worked on Michelle Williams's costumes for the 2010 film *Blue Valentine*, which was filmed in Scranton. Domenick's name appears in the film's credits. (Courtesy of Domenick Mangiola.)

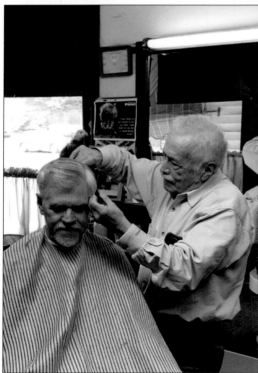

Robert Genovese now runs Dunmore's oldest continually run barbershop, which opened in 1936. Robert learned the trade from his father, Anthony, and has worked as a barber since his 20s. He also worked as a barber at the Tobyhanna Army Depot and as a truck driver. The barbershop still has most of its original fixtures. In this picture, Robert is cutting the hair of Gary Duncan, founder of the Dunmore Neighborhood Watch. (Courtesy of Gary Duncan.)

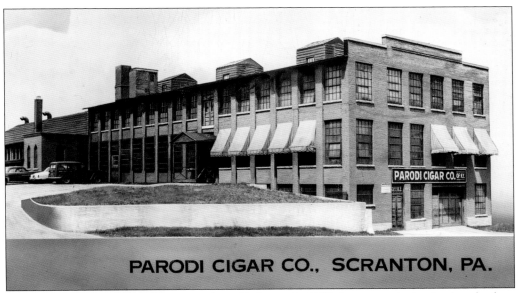

PARODI CIGAR CO., SCRANTON, PA.

The Suraci Brothers Cigar Company formally began in 1912, but traces its beginnings back to the early 1900s when brothers Dominic, Anthony, and Frank Suraci arrived in the United States from the region of Calabria. The Suraci brothers were skilled in the craft of hand rolling Toscani cigars. They first operated a Scranton facility, Licata Cigar Company, during the 1920s. The Suraci brothers purchased the New Jersey–based Parodi Cigar Company during a bank liquidation sale in 1925. (Courtesy of the Avanti Cigar Company.)

Following the 1929 stock market crash, both Anthony and Frank Suraci decided to leave the New York City area and move to Scranton, where they worked for Licata Cigars. The Licata Cigar Company allowed the brothers to produce Parodi Cigars. The Suraci brothers eventually bought out Licata in 1932. Scranton-based Parodi Cigars steadily grew in popularity throughout the 1930s and 1940s, especially in predominantly Italian areas. (Courtesy of the Avanti Cigar Company.)

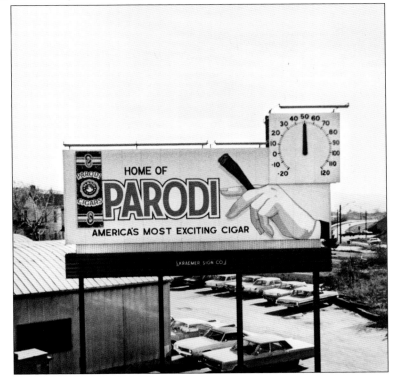

Parodi Cigar Company reorganized as Avanti Cigar Company in 1982. Located in North Scranton for more than a generation, the company moved operations to Dunmore in 2013. (Courtesy of the Avanti Cigar Company.)

Now in its fourth generation, Avanti Cigar Company is the only Lackawanna County–based Toscani cigar manufacturer. In 2010, the Avanti Cigar Company began additional operations in Europe, making it one of the region's predominant international companies. Cigars are still hand rolled at Avanti's Dunmore plant. (Courtesy of the Avanti Cigar Company.)

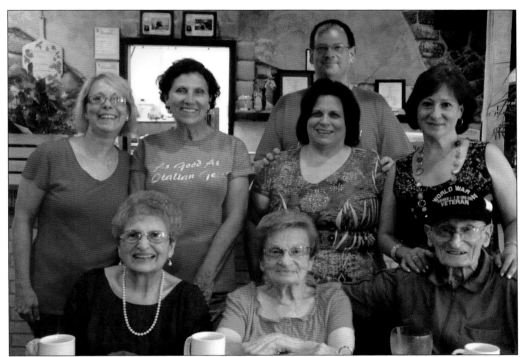

Founded in 2006 by Toni and Darryl Bartlett, A Little Pizza Heaven in Scranton's Green Ridge section incorporates their family's Italian recipes along with new twists on old favorites. The restaurant offers made-from-scratch pasta dishes, as well as homemade desserts and unique pizza flavors. During the Christmas holiday season, it offers a traditional Italian Feast of the Seven Fishes; and during the Easter season, it offers homemade Italian Easter pizza, or *pizza chiena*. (Courtesy of A Little Pizza Heaven.)

Fleetville resident and Brooklyn, New York, native Peter Tafuri claims ancestry from Basilicata, Campania, and Molise. He is the author of *The Christmas Dog* and *Famous Italians You Probably Never Heard Of*, both published by his own company, Frost Pocket Farm Books. He is also an intermittent columnist for the *Italo-Americano* and the *Sons and Daughters of Italy Times*. (Courtesy of Peter Tafuri.)

Old Forge native Gene Talerico served Lackawanna County as assistant district attorney for 16 years, during which time he prosecuted 27 cases as lead or co-prosecutor and 16 as lead prosecutor, including three death penalty hearings. He is the author of Lackawanna County's Child Abuse Protocol and was a special assistant United States attorney for the Middle District of Pennsylvania. A tireless advocate for children, Talerico also serves as president of Marley's Mission, a nonprofit organization that provides equine-assisted psychotherapy to children who have experienced trauma. (Courtesy of Gene Talerico.)

Scranton resident and New York native Yolanda Regina Battaglia is the founder of the Scranton chapter of Young People in Recovery, which seeks to assist adolescents and young adults who are recovering from substance abuse. She created the group in 2016 as a way to proactively respond to the opioid crisis affecting Lackawanna County. Partnering with area organizations, including United Neighborhood Centers (UNC), Young People in Recovery hopes to provide as many resources as possible to stop addiction before it starts. (Courtesy of Yolanda Regina Battaglia.)

Two

GOD PROVIDES

A chi bene crede, Dio provvede.
(Have faith and God will provide. Literal translation: "To
the one who believes well, God provides.")

For an Italian American community, its strongest expressions of pride are often found in the form of a festival, usually tied to a Catholic saint or religious observance—and Lackawanna County is no exception.

In Italy, town festivals are held annually as a way to honor a patron saint and to ask for his or her blessing for the town. The festivals usually have a special Catholic Mass, a street procession with a statue of the patron saint, music, special food, and evening fireworks. The festivals that the immigrants brought to Lackawanna County also follow a similar format, although the food often is not strictly limited to Italian cuisine, allowing people of all ethnic backgrounds the opportunity to join the celebration.

Lackawanna County's Italian festival season begins in May with "La Corsa dei Ceri," or the Race of the Saints, in Jessup and ends in September with a festival in honor of Our Lady of Constantinople in Old Forge. In between these festivals are other observances, processions, and celebrations—all tied to keeping ethnic traditions alive and celebrating those who came from all over Italy to settle in the region.

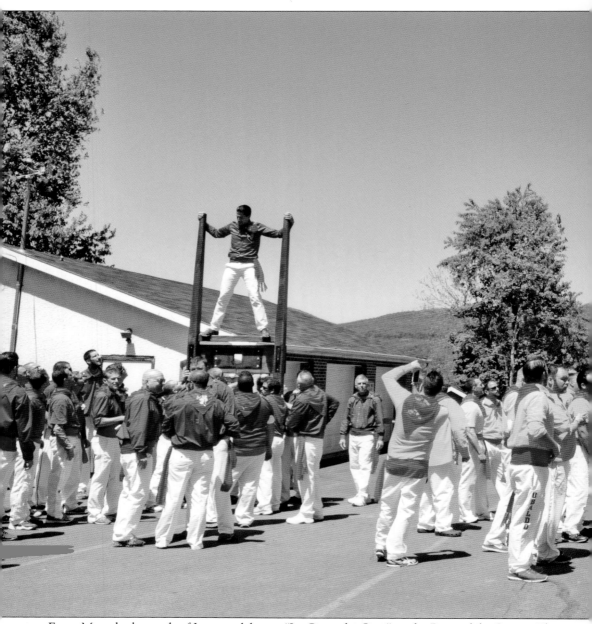

Every May, the borough of Jessup celebrates "La Corsa dei Ceri," or the Race of the Saints. The *ceri* are three wooden structures displaying statues of SS. Anthony, George, and Ubaldo. The race tests strength, as each team must try to keep its *cero* perpendicular to the street. If a cero is dropped, it is considered a disgrace. "La Corsa dei Ceri" was brought to Jessup by immigrants

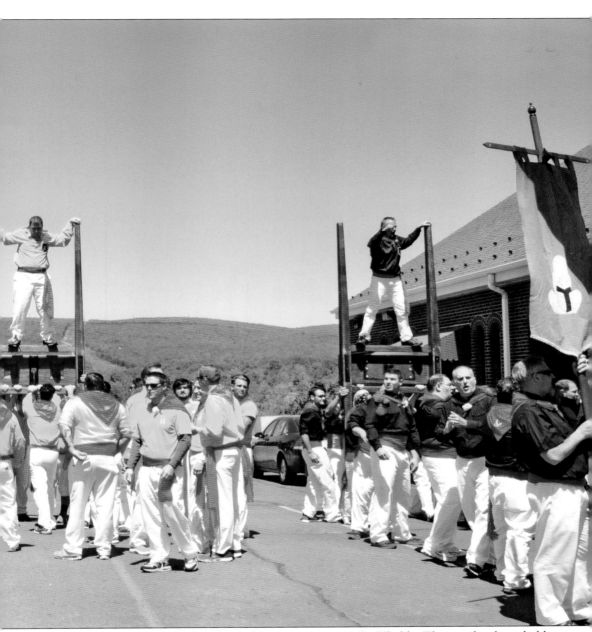

from Gubbio, in the region of Umbria, whose patron saint is St. Ubaldo. The race has been held all over the world, but is most notable in Gubbio and Jessup, due to the sister city relationship between the two towns. (Courtesy of Linda Bonacci Anelli.)

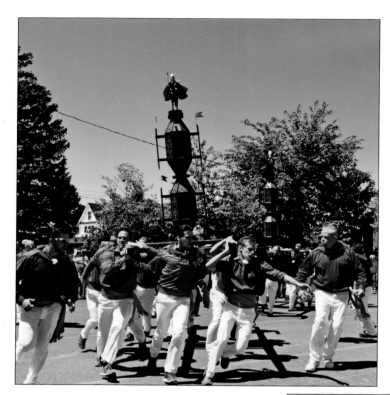

The Family (team) of St. George dresses in blue shirts with white trousers and a red sash. St. George is said to represent Gubbio's tradesmen and merchants. (Courtesy of Linda Bonacci Anelli.)

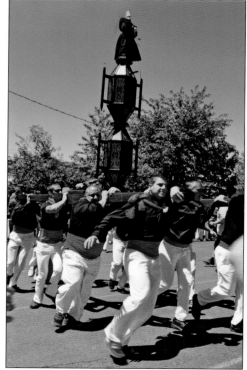

The Family of St. Anthony dresses in black shirts with white trousers and a red sash. St. Anthony is said to represent Gubbio's peasants and laboring classes. (Courtesy of Linda Bonacci Anelli.)

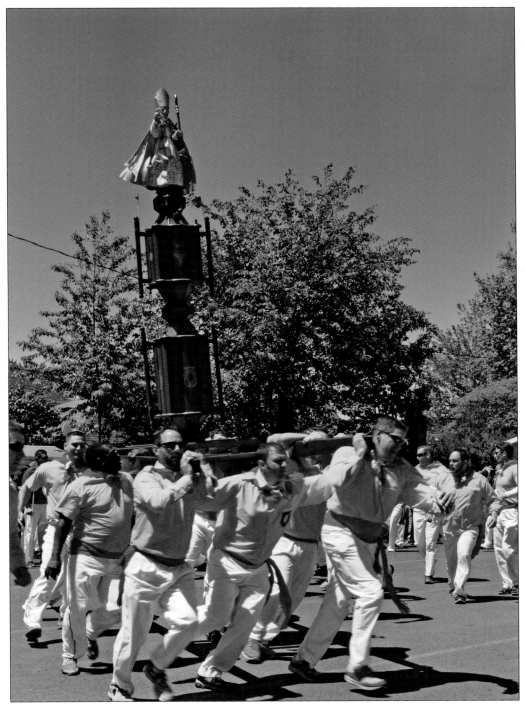

Finally, the Family of St. Ubaldo dresses in yellow shirts with white trousers and a red sash. St. Ubaldo is heralded as the patron of Gubbio's stonemasons. (Courtesy of Linda Bonacci Anelli.)

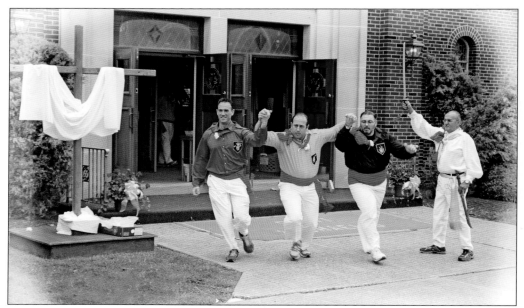

Each *cero* is carried by 10 men, known as the *ceraioli*. The leader of each group of ceraioli is known as the *capodieci*, which translates to "head of ten." On the day of "La Corsa dei Ceri," a traditional Mass is celebrated at Jessup's Queen of Angels parish, where the ceri are blessed. Here, the capodieci for SS. Anthony, George, and Ubaldo, exit the church after the blessing of the ceri. (Courtesy of Linda Bonacci Anelli.)

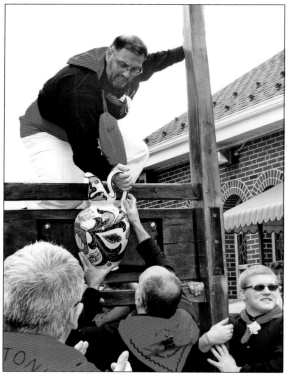

Immediately after the Mass, the statues of each saint are put in place on their platforms, which is then followed by the traditional tossing of ceramic vases, known as *brocche*. Here, the capodieci for St. Anthony receives his *brocca*. (Courtesy of Linda Bonacci Anelli.)

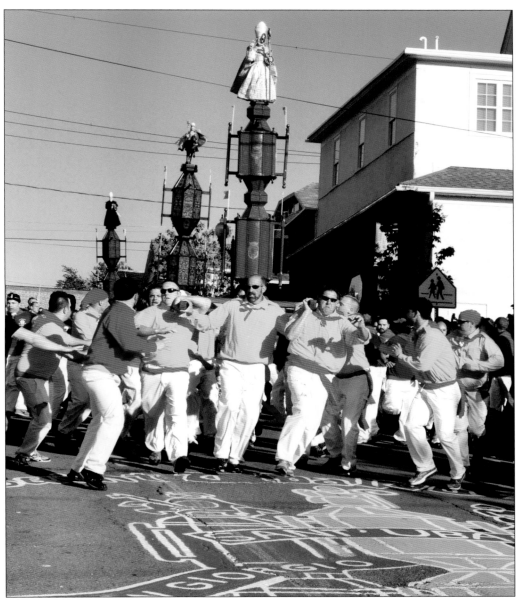

On the afternoon of "La Corsa dei Ceri," a procession steps off from Jessup's St. Ubaldo Cultural Center and finishes at the intersection of Powell and Ward Streets, which is where the actual race begins. The ceraioli circle around the block and then charge down Church Street. At the bottom of Church Street, they turn around and head back up the steep incline, which is known as "taking the hill." (Courtesy of Linda Bonacci Anelli.)

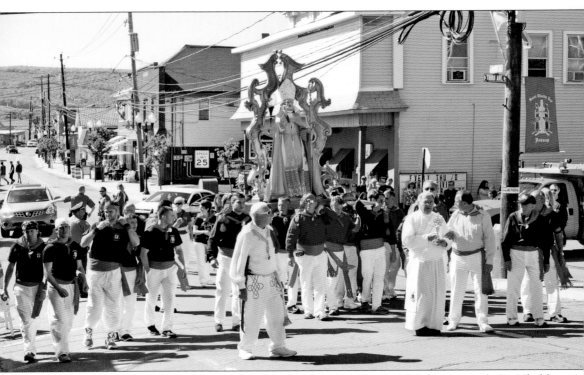

Legend states that upon his return from negotiations with Frederick I (Barbarossa), St. Ubaldo was placed on a platform and paraded through the streets of Gubbio to show citizens that he was safe. From the 1970s, when a group of Jessup residents traveled to Gubbio to establish contact, residents of both Jessup and Gubbio have gone to great lengths to strengthen the towns' shared heritage. In this photograph is the statue of St. Ubaldo that was recently sent to Jessup from Gubbio in recognition of the special relationship between the two towns. (Courtesy of Linda Bonacci Anelli.)

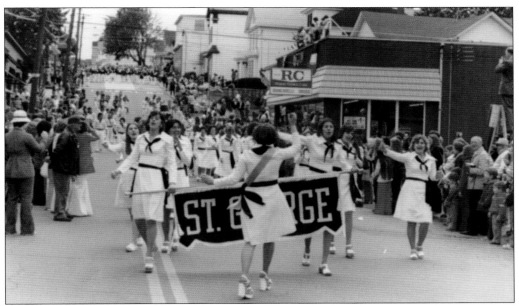

Jessup's celebrations in honor of St. Ubaldo were suspended in 1952 because of the Korean War, but were revived in 1976 as a part of Jessup's centennial and the American bicentennial celebration as a way to honor the town's Italian heritage. Pictured is the Family of St. George proceeding down Church Street in Jessup prior to the 1976 "La Corsa dei Ceri." (Courtesy of Corinne Sebastianelli.)

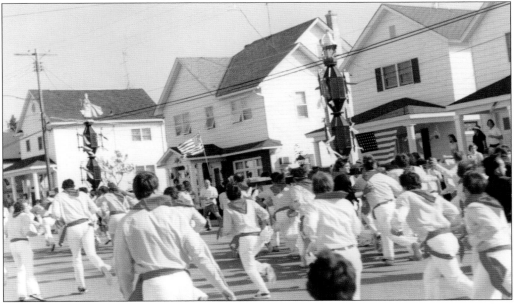

The 1976 "La Corsa dei Ceri" was one of the town's largest celebrations of its Italian heritage to date. The Blue Knights parachutes were part of a community celebration following the race and there was also a special children's race that continues to this day. A group of Jessup residents also brought "La Corsa dei Ceri" to Scranton's annual St. Patrick's Day parade that year, demonstrating the close ties between all ethnicities in Lackawanna County. (Courtesy of Corinne Sebastianelli.)

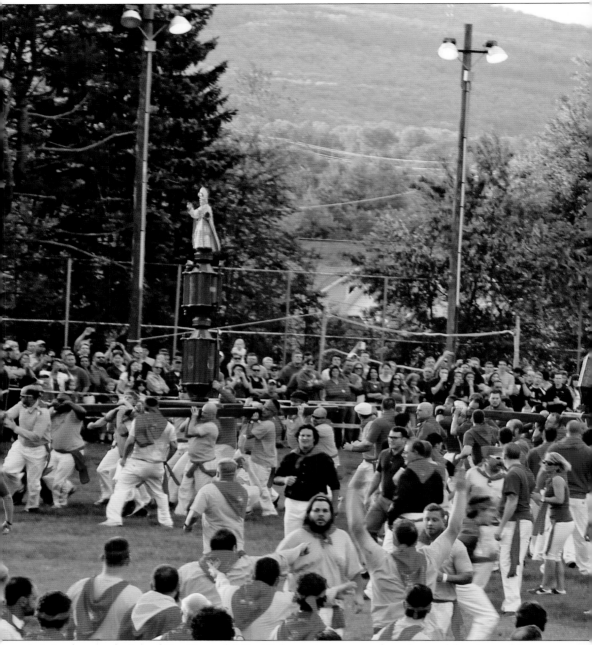

At the conclusion of "La Corsa dei Ceri," the entire town gathers for a celebration at Veterans Memorial Field, where each team attempts to be the first to remove its saint from his platform and

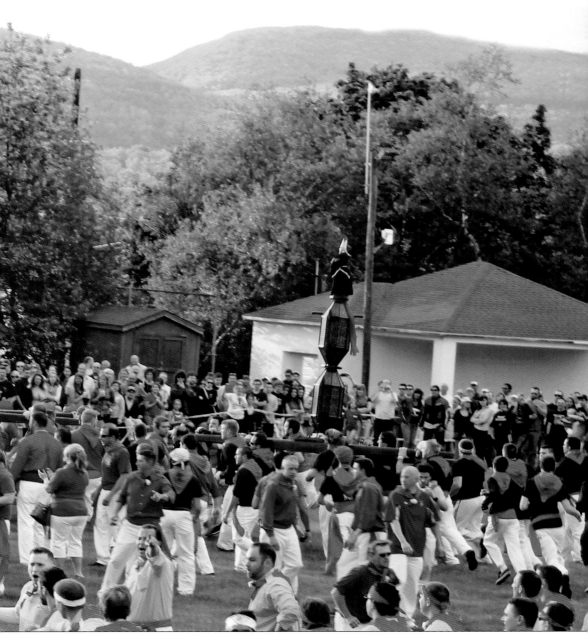

carry it up an embankment in the park. The day ends with a candlelight procession where the saints are returned to the St. Ubaldo Society Cultural Center. (Courtesy of Linda Bonacci Anelli.)

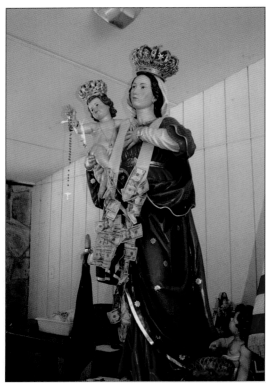

Many residents of Scranton can claim ancestry from the town of San Mango d'Aquino in Calabria, where there is an annual procession in honor of the Virgin Mary as the "Madonna della Buda." Immigrants to the region brought the same procession to Scranton, where it is held annually at McDade Park on Father's Day weekend. (Courtesy of the San Mango d'Aquino Society.)

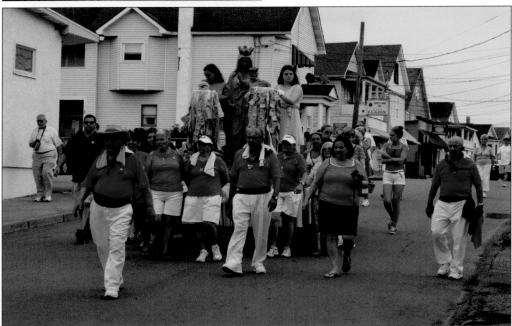

For nearly 90 years, the Italian community of Carbondale has celebrated the Feast of Our Lady of Mount Carmel in mid-July. The Church of Our Lady of Mount Carmel hosts a picnic on the Thursday prior to the Sunday closest to the feast day. (Courtesy of Nancy K. Free.)

During the 1980s, the Church of Our Lady of Mount Carmel acquired the old Lincoln School on Fairview Street in Carbondale. Once that school was razed and the property cleared, the feast was moved from the Green Street Playground, which no longer exists. (Courtesy of Nancy K. Free.)

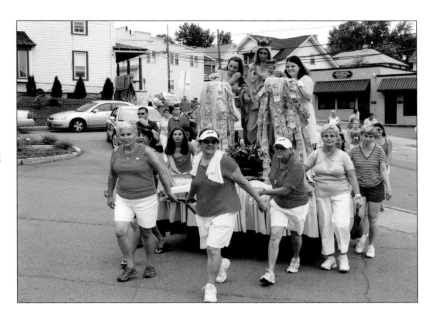

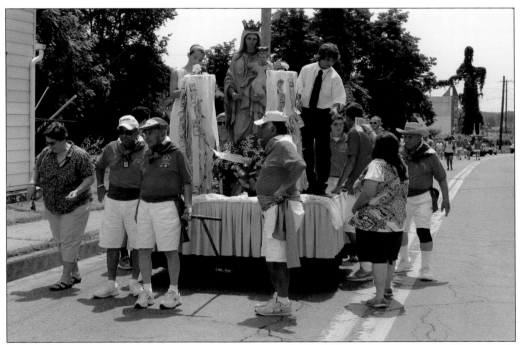

Over the years, the Feast of Our Lady of Mount Carmel offered live entertainment and homemade Italian foods. During the 1970s, it also boasted a beer tent and a greased pole and greased pig contest. The pole was either a metal pole or a stripped tree trunk slathered with grease and contestants attempted to climb to the top. The greased pig was let loose in a pen and contestants tried to catch it. (Courtesy of Nancy K. Free.)

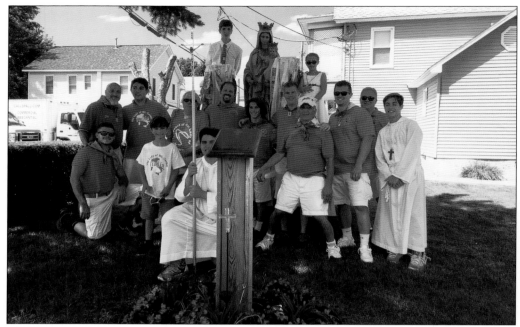

The Feast in honor of Our Lady of Mount Carmel includes a procession in her honor. Before continuing on its route throughout the streets of Carbondale, the procession traditionally stops at the site of the original location of Our Lady of Mount Carmel Church on the corner of Brown and Villa Streets. The original church was constructed by Italian immigrants in the early 1800s and used until the present church was built in 1900. (Courtesy of Patrick Cassaro.)

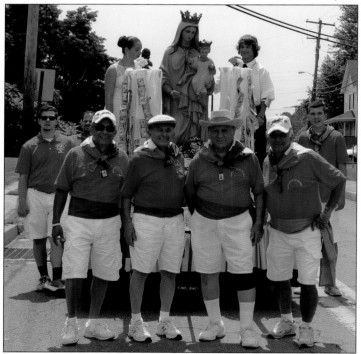

The procession in honor of Our Lady of Mount Carmel takes place immediately following Mass on the Sunday closest to her feast day. A statue of Our Lady of Mount Carmel is carried through the streets of Carbondale and residents can pin monetary offerings to her sash as she goes by. At the conclusion of the procession, the women of the church "bring" Our Lady home, while the men jog ahead to prepare the church for her return. (Courtesy of Nancy K. Free.)

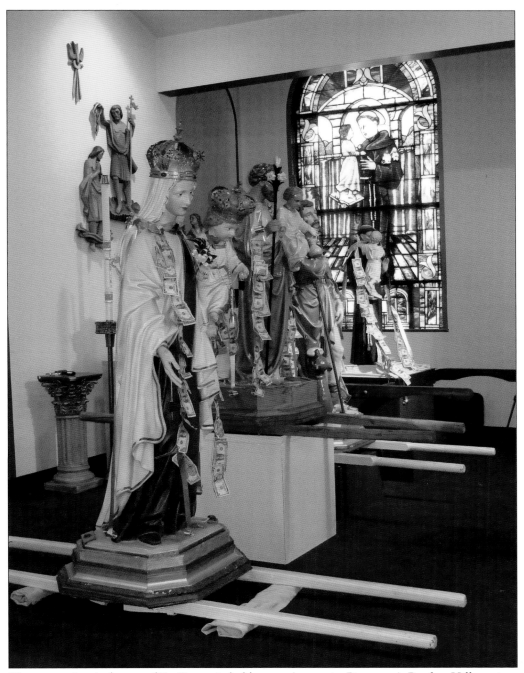

The procession in honor of St. Rocco is held every August in Dunmore's Bunker Hill section. For more than 100 years, it has taken place on the last day of a three-day festival in honor of the saint. The men of the parish carry statues of St. Rocco, the Blessed Virgin Mary, St. Joseph, and St. Anthony over a 1.5-mile trail. Here, the statues have just been blessed during a Mass at St. Rocco's Church before the procession begins. (Author's collection.)

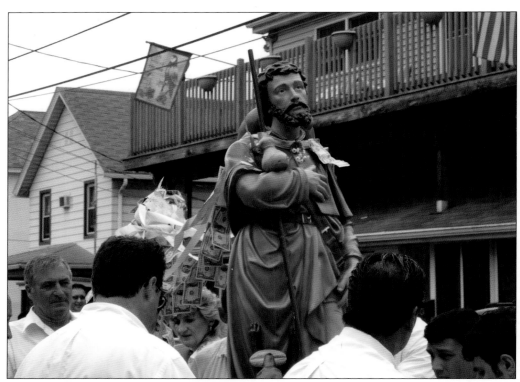

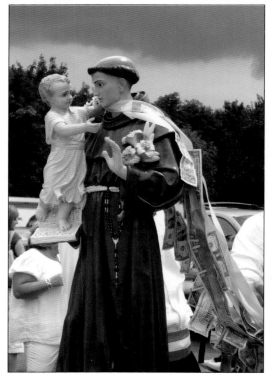

Legend has it that St. Rocco, the patron saint of the invalid, saved the citizens of Guardia dei Lombardi, Campania, in 1656 when a deadly plague and drought swept through the town, killing 1,100 of its 1,475 residents. Because his intercession saved the town from total destruction, St. Rocco then became patron saint of Guardia dei Lombardi. When Guardiese immigrants arrived in Dunmore, they brought the tradition with them. (Author's collection.)

Following the merger of St. Anthony and St. Rocco Parishes in Dunmore to form the Parish of SS. Anthony and Rocco, a statue of St. Anthony was added to the procession as a way to unite the two Italian-origin parishes. St. Anthony Parish was traditionally known as where Italian Americans who claimed ancestry from the town of Calitri worshipped, while St. Rocco was where the Guardiesi attended Mass. Calitri and Guardia dei Lombardi are both located in the Province of Avellino in the Campania region of Italy. (Author's collection.)

During the Mass preceding the procession and during the procession itself, attendees have the opportunity to be blessed with the relic of St. Rocco. At the time of the blessing, the saint is asked to protect the person from afflictions of mind and body. (Author's collection.)

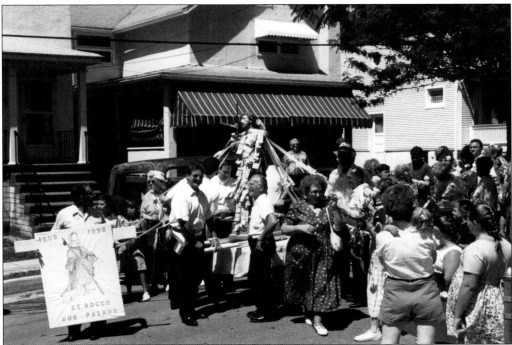

The St. Rocco procession has become an integral part in the life of residents of Dunmore's Bunker Hill section, with people leaving their homes to greet the saints when they pass by. In this photograph from the 1990s, residents line up to place monetary offerings on St. Rocco's sash before he leaves their block. (Courtesy of Carlo Pisa.)

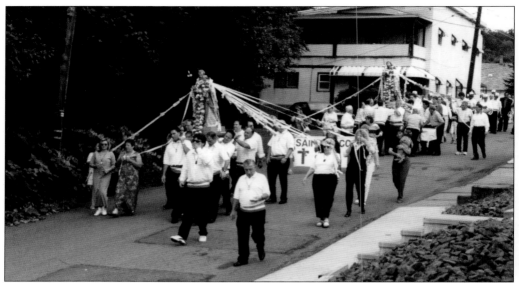

Part of the procession's trek leads the statues downhill, as well as partly into the city of Scranton, which borders Dunmore's Bunker Hill. Even though the practice of this procession has slowly lost popularity in recent years, more than 1,000 people of all ethnic origins still participate in the St. Rocco Festival. (Courtesy of Carlo Pisa.)

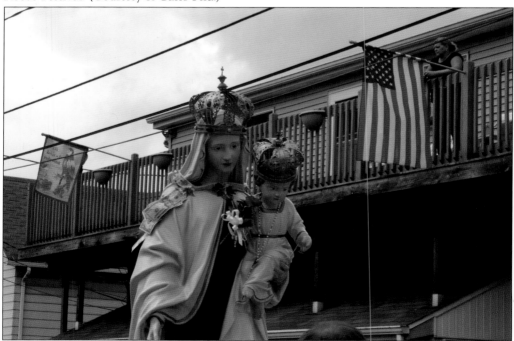

The actual St. Rocco Festival provides homemade food and live entertainment and also serves as a collaboration point with another Dunmore-based event called Angel Night, where lanterns are released in memory of anyone who has passed away. Lanterns are lit at the St. Rocco Festival on Friday evening. Other Angel Night locations include Dunmore High School, Sherwood Park, and private residences. (Author's collection.)

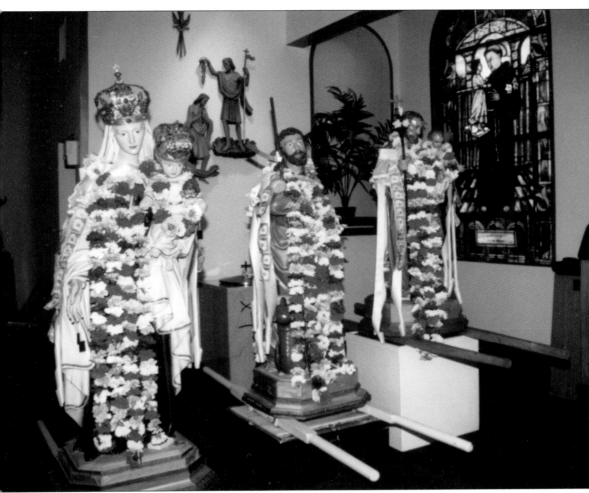

After the procession, the saints are then placed back on the altar for private veneration while the festival takes place outside. This photograph was taken in the 1990s when St. Rocco's Church was still a stand-alone parish and before St. Anthony was added to the procession. (Courtesy of Carlo Pisa.)

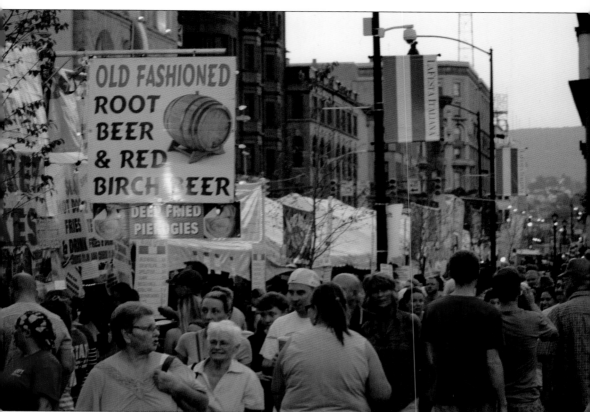

Lackawanna County is home to "La Festa Italiana," the largest Italian American festival in the region. "La Festa" is held annually over Labor Day weekend on Courthouse Square in Scranton. The festival was extended to four days in 2016 to include First Friday Scranton. (Courtesy of Michael Taluto.)

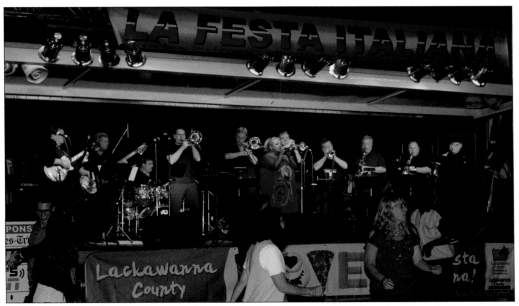

"La Festa" regularly welcomes a wide variety of local, regional, and national musical acts, often performing traditional Italian American music. The festival was originally held over Columbus Day weekend, but due to inclement weather, organizers felt a change in season was needed. It was moved to Labor Day weekend in 1981 and has been held at that time ever since. (Courtesy of Michael Taluto.)

Various novelty items are available for purchase at "La Festa Italiana," often reflecting a regional theme. For example, many items feature a stylized "Electric City" sign, which is the symbol of the city of Scranton and is a remnant of the city's heyday as the "Coal Capital of the World." "La Festa Italiana" takes place on Scranton's Courthouse Square because it is the city's equivalent of a piazza, the town square and the center of the community in Italy. (Courtesy of Michael Taluto.)

Authentic Italian food is a staple at "La Festa Italiana." Vendors occupy all four sides of Courthouse Square in Scranton, offering a wide variety of Italian cuisine made by some of the region's premier Italian restaurants. (Courtesy of Michael Taluto.)

While Italian food is the star of "La Festa Italiana," the festival has grown to reflect the region's evolving ethnic traditions. Festivalgoers can sample not only unique Italian foods, such as this giant cannoli, but also pierogies, potato pancakes, and other non-Italian regional cuisine. (Courtesy of Michael Taluto.)

"La Festa Italiana" is a fun and festive way for the region's Italian American community to celebrate its heritage. It also includes a Mass celebrated in Italian at St. Peter's Cathedral in Scranton, where volunteers proceed into the cathedral bearing the coats of arms from various Italian cities whose citizens immigrated to Scranton and its surrounding areas. (Courtesy of Michael Taluto.)

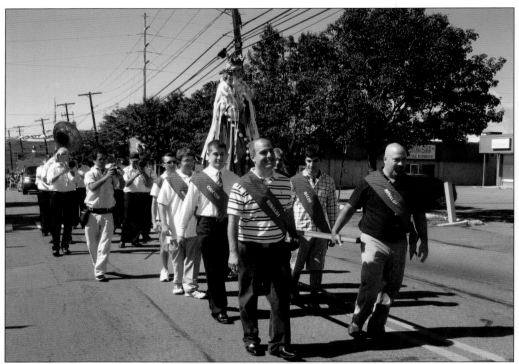

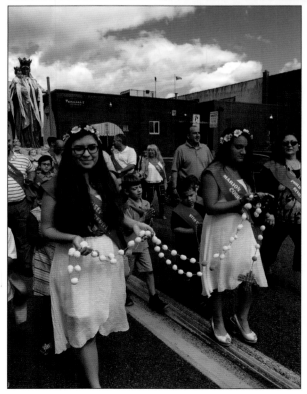

The procession in honor of Our Lady of Constantinople occurs in Old Forge, where most residents are descendants of immigrants from the village of Felitto, Campania. When these immigrants settled in Old Forge, they started an annual procession and festival to honor Our Lady of Constantinople, whom they believed helped them survive hard times. Veneration of Our Lady of Constantinople dates back to the 1790s in Felitto. (Courtesy of Joanna Reviello.)

Both the festival and procession in honor of Our Lady of Constantinople were discontinued in the 1930s, but revived in the 1980s by the Felittese Association of Old Forge. The procession begins at St. Mary's Church in Old Forge, part of Prince of Peace Parish, and proceeds down Grace Street to Main Street, making its way to the chapel in honor of Our Lady of Constantinople on Third Street. (Courtesy of Joanna Reviello.)

Children from Prince of Peace Parish place flowers in front of a statue of the Blessed Virgin Mary as Our Lady of Constantinople during a Mass in her honor at St. Mary's Church. These flowers represent their desire for a blessing on their families and are then carried throughout Old Forge along with the procession and brought to the chapel. (Courtesy of Joanna Reviello.)

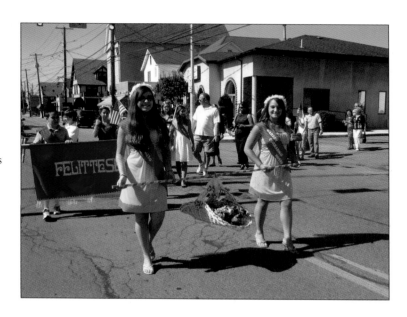

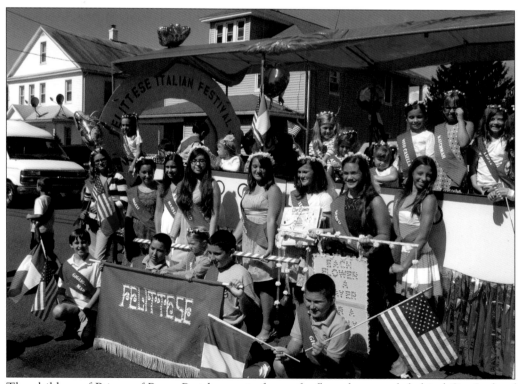

The children of Prince of Peace Parish pose in front of a float that travels behind Our Lady of Constantinople. The float is in the shape of a boat, meant to represent the various ships that brought the original immigrants from Felitto to Old Forge. A marching band also accompanies the troupe. (Courtesy of Joanna Reviello.)

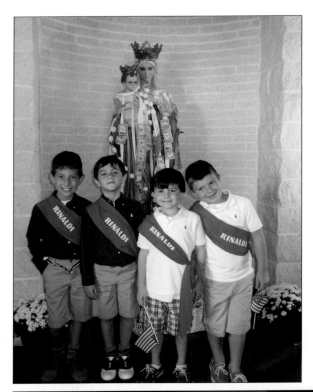

The children of the Rinaldi family of Old Forge pose in front of the statue of Our Lady of Constantinople after her arrival in the chapel. Townspeople and children wear red sashes emblazoned with the names of their immigrant ancestors as a way to honor them during the procession. (Courtesy of Joanna Reviello.)

The procession in honor of Our Lady of Constantinople is the culmination of Old Forge's three-day Felittese Italian Festival in September. The festival features homemade Italian food and takes place on the grounds of the chapel on Third Street. Here, members of the Felittese Association make traditional Italian *pizza fritta*, or fried dough. (Courtesy of Joanna Reviello)

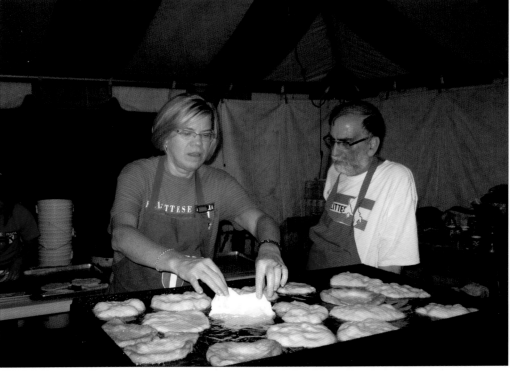

Three

WHERE THERE'S A WILL

A chi vuole, non mancano i soldi.
(Where there's a will, there's a way. Literal translation: "To
the person who wants, money is not lacking.")

Preserving Italian heritage locally is something that the Italians of Lackawanna County have done exceptionally well. Every Italian enclave, from Scranton to Dunmore to Jessup to Carbondale, has some sort of Italian American organization located within its confines.

Italian heritage societies in Lackawanna County first sprang up in the heyday of immigration to the region during the late 1800s and early 1900s. Many of the organizations were tied to church or parish life, and gave the newly arrived Italians the chance to maintain their ties to their homeland while meeting new people and putting down roots in the United States.

Over the years, due to dwindling populations and intermarriage between ethnicities, many of these societies and organizations either disbanded or folded into larger, nationally based organizations, such as the Order of the Sons of Italy and UNICO National, both of which still have a presence in Lackawanna County today. Other societies, such as the San Cataldo Club in Dunmore and the Victor Alfieri Club in Scranton, have remained and even grown over the years.

The Lackawanna County government also does what it can to make Italian history and heritage available to all. From an annual bocce tournament to the Italian flag–raising ceremony on Scranton's Courthouse Square every October, the county itself knows that celebrating the immigrants who came to settle in the region helps weave their traditions into everyone's daily life.

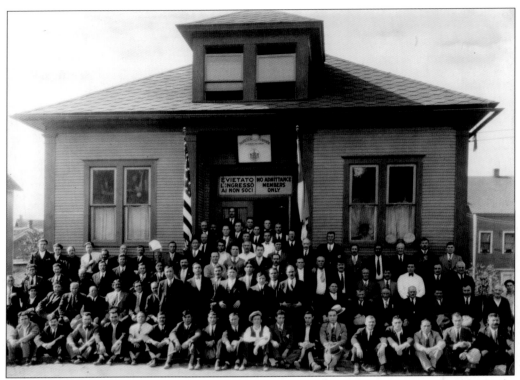

A large number of the Italian population of Dunmore can trace their roots to San Cataldo, Sicily. In 1904, a group of men from San Cataldo organized the Società San Cataldese Cooperativa di Mutuo Soccorso. The Commonwealth of Pennsylvania formally recognized the San Cataldo Club as a club on May 15, 1906. In this photograph, members stand outside the San Cataldo Clubhouse on Elizabeth Street in Dunmore in 1929. (Courtesy of Santo "Sandy" Cancelleri.)

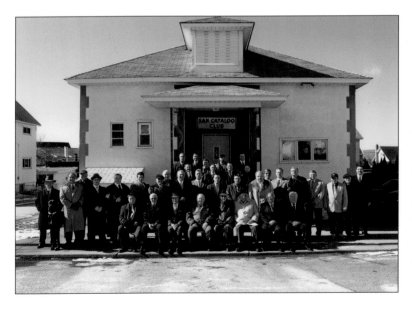

Descendants of the original San Cataldo Club members in the previous photograph, as well as current club members, stand outside the San Cataldo Clubhouse in Dunmore in 2006 in celebration of the club's centennial. (Courtesy of Santo "Sandy" Cancelleri.)

The now defunct Dante Literary Society was formed in 1934 in Scranton's South Side by a group of Italian American women and men seeking to improve their educations as well as their public speaking skills. Named after Dante Alighieri, known as the "father" of Italian literature, the society was formally incorporated in 1936. Membership was so large by 1948 that society members began planning their own clubhouse, which opened in 1953. Waning membership led club officials to disband the Dante Literary Society in 2016 after 82 years. (Author's collection.)

The Keystone Chapter of UNICO National, the nation's largest Italian American service-based organization, was formally chartered on April 14, 2012, in order to fill a void in the region. The chapter was sponsored by the neighboring Carbondale Chapter of UNICO National. Keystone's Charter Night was the largest on record for the entire organization and the chapter is the second-largest nationally, following the Scranton chapter. (Courtesy of Mark McDade.)

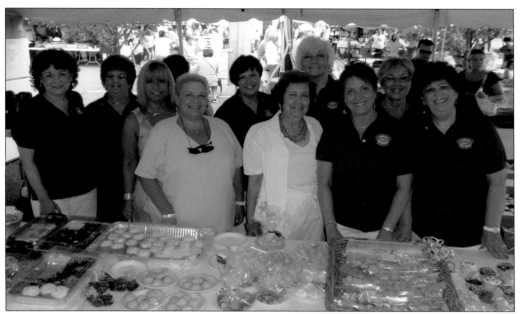

Part of the Keystone Chapter of UNICO National's commitment to serving the community is demonstrated through participation in local and regional benefit activities. In this photograph, the chapter's "Le Sorelle" committee works a bake sale at the annual St. Joseph's Center Summer Festival, which is the center's largest annual fundraiser. (Courtesy of Mark McDade.)

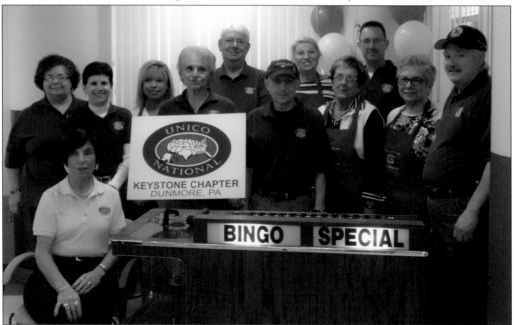

The Keystone Chapter of UNICO National also supports the Gino J. Merli Veterans' Center in Scranton. Here, members hold a bingo social for the center's residents. Keystone UNICO also supports local and national scholarships as well as cancer and Cooley's anemia research, among other initiatives. (Courtesy of Mark McDade.)

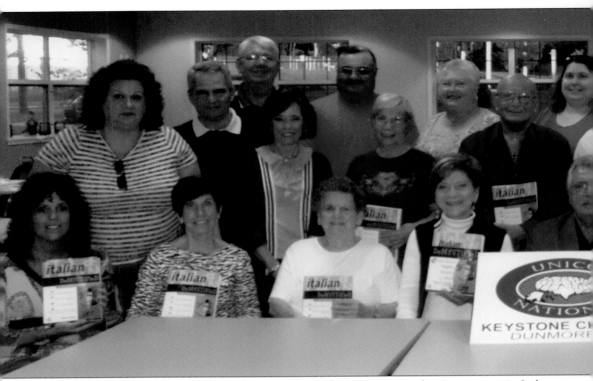

As an Italian American–based service organization, UNICO National strives to sustain Italian American heritage–related activities throughout the United States, and the Keystone Chapter is no exception. In this photograph, students are gathered for the chapter's first Italian class, held at the Dunmore Community Center. The Italian classes are designed to prepare students for eventual

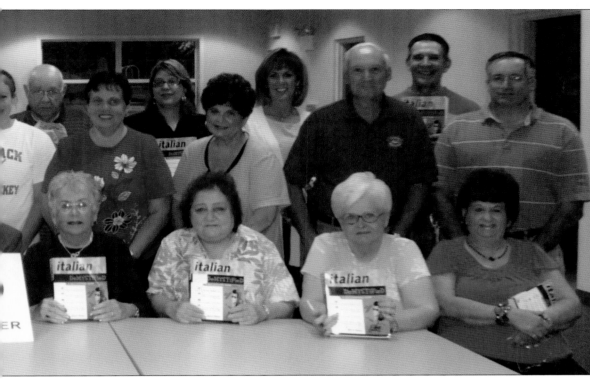

trips to Italy or other Italian-speaking regions by giving them a base in conversational Italian. Students then have the option of continuing their Italian studies either through the chapter or through regional colleges and universities. (Courtesy of Mark McDade.)

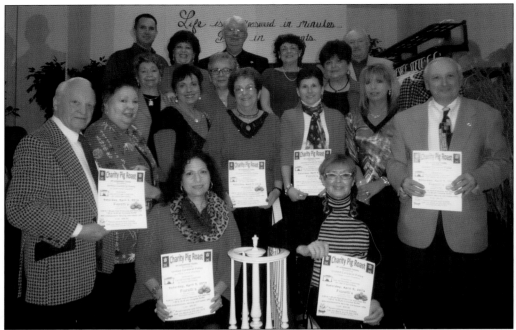

One of Keystone UNICO's major fundraisers is an annual charity pig roast. The event was originally conceived as a way to celebrate the chapter's one-year anniversary. Offering a luau, raffles, live music, and entertainment, the charity pig roast seeks to give members the chance to network in a relaxed, fun atmosphere. (Courtesy of Mark McDade.)

Keystone UNICO also offers an annual golf tournament benefitting charities throughout northeastern Pennsylvania. Tournament proceeds also help fund a wide variety of scholarships for both high school and college students from Lackawanna County. (Courtesy of Mark McDade.)

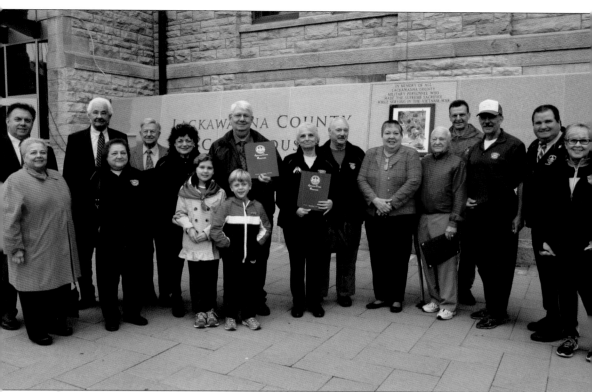

In this photograph, Keystone UNICO members gather with the Lackawanna County Commissioners for the inaugural Columbus Day Italian flag–raising ceremony in October 2012. The ceremony was one of the chapter's first initiatives and it welcomed representatives from all of Lackawanna County's Italian American organizations. The Italian flag flies in front of the Lackawanna County Courthouse throughout the month of October. October is designated as National Italian American Heritage Month. (Courtesy of Mark McDade.)

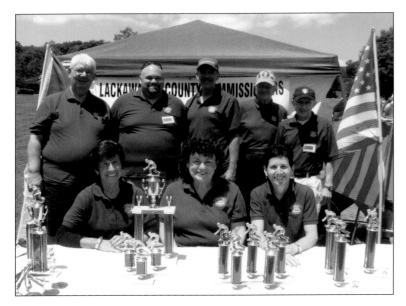

For the past 25 years, the Lackawanna County Commissioners have hosted a bocce tournament at McDade Park in Scranton. In this photograph, the team from Keystone UNICO poses with its trophies following the daylong tournament. (Courtesy of Mark McDade.)

The name *bocce* is the plural of the Italian word *boccia*, which means "bowl" in the sport sense. Developed into its present form in Italy, a match begins with a randomly chosen side being given the opportunity to throw a jack called the *boccino* (also known as a *pallino*) into the court. Players then throw the bocce ball in order to either knock the boccino or another ball away to reach a more favorable position. (Courtesy of Lackawanna County.)

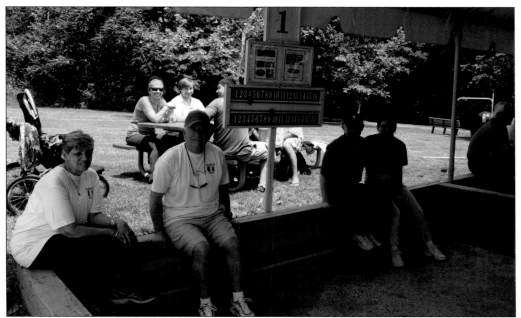

Bocce is an extremely popular sport among Italian ethnic enclaves throughout the world. It is played in Europe, Australia, North America, and South America. Initially played among Italian immigrants, it eventually became more popular with their descendants and the community at large. It is in this spirit that Lackawanna County began hosting its annual tournament. (Courtesy of Lackawanna County.)

The Lackawanna County Commissioners' annual bocce tournament features 24 teams with more than 96 players in men's, women's, and mixed teams categories. Teams are comprised of bocce aficionados, area businesses, Italian American civic organizations, and anyone else who wishes to play. The tournament is open to all skill levels. (Courtesy of Lackawanna County.)

In 2014, the City of Scranton and the Town of Guardia dei Lombardi in the province of Avellino, Campania, Italy, entered into a sister city relationship. This relationship recognizes the large influx of Guardiese immigrants who settled in the Bunker Hill sections of both Scranton and Dunmore. The Borough of Dunmore also entered into a sister city relationship with Guardia dei Lombardi in 2016. Pictured is Piazza Vittoria, the main town square of Guardia dei Lombardi. (Author's collection.)

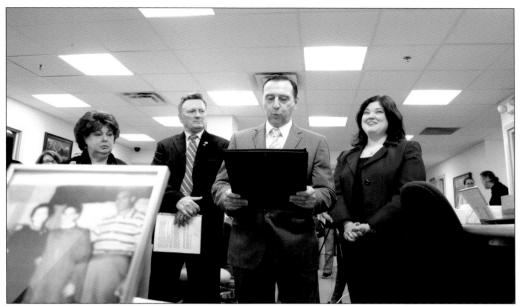

The official proclamation of the sister city relationship between Scranton and Guardia dei Lombardi was made during a First Friday exhibit at Lackawanna College called *Celebrating Guardia dei Lombardi*, sponsored by the heritage committee of the Scranton Chapter of UNICO National. Pictured is Scranton mayor William Courtright reading the formal proclamation. (Courtesy of Lackawanna College.)

Part of the Scranton/Guardia dei Lombardi sister city celebration included a photo exhibit featuring images of the Guardiese immigrants after they settled in Lackawanna County. A call for photographs was made through the *Scranton Times-Tribune* and via social media, with more than 100 photographs contributed to the display. (Courtesy of Lackawanna College.)

The sister city celebration also gave attendees the chance to share their families' stories about their connections to Guardia dei Lombardi. Pictured is Monsignor Constantine Siconolfi, the founder of the St. Francis of Assisi Food Kitchen in downtown Scranton. Monsignor Siconolfi's family settled in the area from Guardia dei Lombardi. When the town was struck by an earthquake in 1980, Monsignor Siconolfi assisted in fundraising efforts by the then Lackawanna County commissioners to assist in recovery. (Courtesy of Lackawanna College.)

Paul DeAntona of Scranton also vividly remembers his family's connections to Guardia dei Lombardi. In his speech during the celebration, he credited his Guardiese heritage with shaping his character as well as his life's path. He called visiting his ancestral town one of the highest points of his life and something he would never forget as long as he lived. (Courtesy of Lackawanna College.)

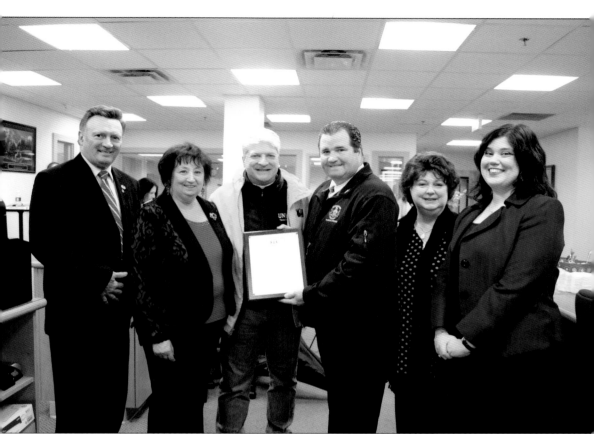

Lackawanna County commissioner Patrick M. O'Malley also attended *Celebrating Guardia dei Lombardi*, where he declared December 5, 2014, as "Guardia dei Lombardi Day" throughout Lackawanna County. With the sister city relationship now being overseen by SIAMO: The Italian-American Heritage Society of Northeastern Pennsylvania, further ties between Lackawanna County and Guardia dei Lombardi have been made, including a joint effort by UNICO Scranton and SIAMO to have Luke Avenue, which is located in both Scranton and Dunmore, bear the honorary designation "Guardia dei Lombardi Way." (Courtesy of Lackawanna College.)

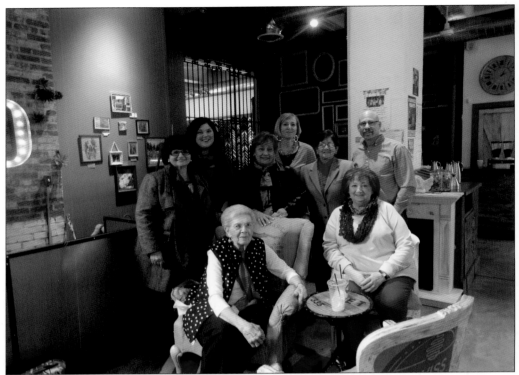

Founded in 2016 as a way to further promote Italian American heritage throughout northeastern Pennsylvania through free educational activities, SIAMO: The Italian-American Heritage Society of Northeastern Pennsylvania holds quarterly Italian-language gatherings for all skill levels. For one hour, Italian speakers can converse in Italian while networking. Pictured is one of the society's first get-togethers at Adezzo in Scranton. (Author's collection.)

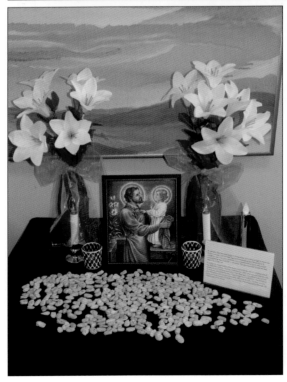

SIAMO also hosts an annual St. Joseph's Day Festival in March in conjunction with the Lackawanna County Library System. St. Joseph is the patron saint of immigrants and of Italian Americans. SIAMO's event boasts a traditional altar to the saint (pictured), complete with fava beans that attendees can take home for luck. The event also features homemade zeppole, the traditional treat for the feast, as well as story time and crafts for children. (Author's collection.)

The Scranton Fringe Festival, an annual performing and visual arts festival held in downtown Scranton, hosted SIAMO for a reading of Italian folk tales from the province of Avellino at the Lackawanna County Children's Library. Members of SIAMO translated the folk tales into English, making the Scranton Fringe Festival the first time that the tales were read in the United States. (Author's collection.)

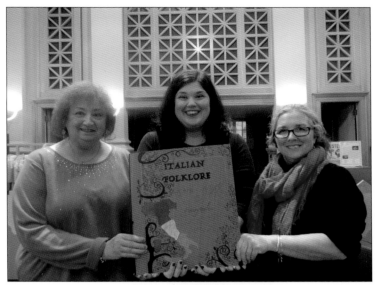

SIAMO also collaborated with the Genealogical Research Society of Northeastern Pennsylvania to bring historian Robert Wolensky to the area to present on Italian American workers in the region's coal mines. A native of northeastern Pennsylvania, Dr. Wolensky is the author of *Anthracite Labor Wars: Tenancy, Italians, and Organized Crime in the Northern Coalfield of Northeastern Pennsylvania, 1897–1959.* (Author's collection.)

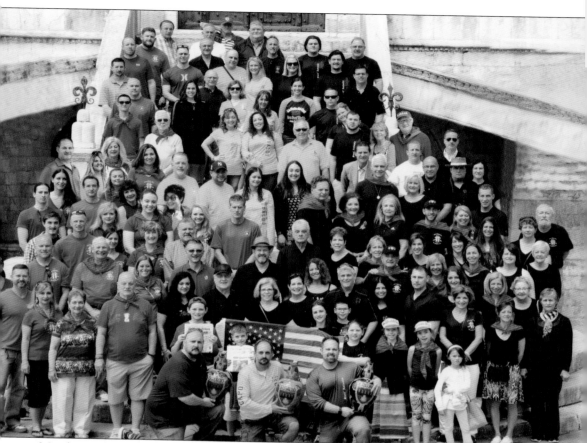

Members of Jessup's Saint Ubaldo Society regularly travel to Gubbio, Italy, where their ancestors came from, to watch "La Corsa dei Ceri" and participate in other cultural activities. In 2016, more than 150 people from Jessup made the trip, including Jessup mayor Beverly Valvano Merkel. All those pictured are wearing the colors of their respective saint families. (Courtesy of Linda Bonacci Anelli.)

The Saint Ubaldo Society was founded as a way to continue strengthen the ties between Jessup and Gubbio while providing year-round events and cultural activities to the region's Italian population. The society runs the Saint Ubaldo Society Cultural Center in Jessup, which houses the *ceri, brocche,* a life-sized statue of St. Ubaldo, and other cultural artifacts relating to "La Corsa dei Ceri" and immigration to Jessup from Gubbio. (Courtesy of Linda Bonacci Anelli.)

In Jessup, each "family" belonging to either St. Ubaldo, St. Anthony, or St. George functions as a team during "La Corsa dei Ceri" as well as a special society during the year leading up to the race. Pictured are Louis Mariani Jr. (right), who has run with the Family of St. George every year since 1976, and Michael Arnoni, who was the Family of St. George's *capodieci* in 2015. (Courtesy of Corinne Sebastianelli.)

The San Mango d'Aquino Society was originally formed as a mutual aid society, designed to help immigrants establish themselves in the region. Today, the San Mango d'Aquino Society is dedicated to preserving its heritage through its annual procession in honor of the Virgin Mary, as well as through other events. (Courtesy of the San Mango d'Aquino Society.)

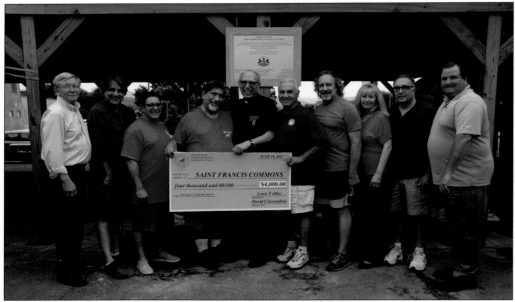

The Lackawanna County commissioners joined representatives from the Old Forge Order of the Sons of Italy Gloria Lodge 815 who presented a donation to St. Francis Commons, a transitional housing facility for homeless veterans located in Scranton. The presentation was made in front of a pavilion that was constructed at Old Forge's Arcaro and Genell Restaurant with Lackawanna County Community Re-Invest funding. (Courtesy of Lackawanna County.)

Four

LOOKING TOWARD THE FUTURE

Ciò che Dio fa è ben fatto.
(Don't worry about the future. Literal translation: "What God does is well done.")

With the advent of new technologies and new family dynamics in today's society, one might think that having strong ties to a bygone generation might not fit in properly with modern life. That is not the case in Lackawanna County for any ethnic group, but especially for Italian Americans. As stated in the introduction to this book, Italian traditions and history have become a part of daily life—from cuisine to the arts and beyond. A person of Italian origin might have designed the building someone passes every day on the way to work or might own the business a person patronizes regularly.

While so many negative stereotypes against Italian Americans do exist, the people and stories portrayed in this book prove that the use of such labels is simply a pointless way to explain something that the person pronouncing such words knows nothing about. The Italians of Lackawanna County are hardworking, upstanding citizens who just wish to celebrate their heritage through example.

It is in leading by example that negative stereotypes can be broken. Through education, negativity can yield way to positivity. Witnessing the stories of the Italian community of this region, one gets the sense that its narrative is just beginning. There are more words to be written and more tales to discover.

The Feast of the Seven Fishes is celebrated by many Italian American families on Christmas Eve. Also known as "La Vigilia," the feast is thought to be a celebration of the story about a fisherman that could not catch any fish, but who then succeeded in catching seven types of fish. The meal may include a combination of anchovies, whiting, lobster, sardines, dried salt cod (*baccalà*), smelts, eels, squid, octopus, shrimp, mussels, and clams. In this picture, Minnie Fischetti Mead of Scranton celebrates the feast with her extended family. (Courtesy of Joan Mead Matsui.)

Located in Scranton's Providence section, Amendola Deli-cious is a family owned-and-operated salumeria, gelateria, and café. The business originally started at Scranton's "La Festa Italiana" in 1998 and, due to popular demand, the Amendola family opened the restaurant in 2013. The Amendola family originally hails from Nicastro (now Lamezia Terme), Calabria. (Courtesy of the Amendola family.)

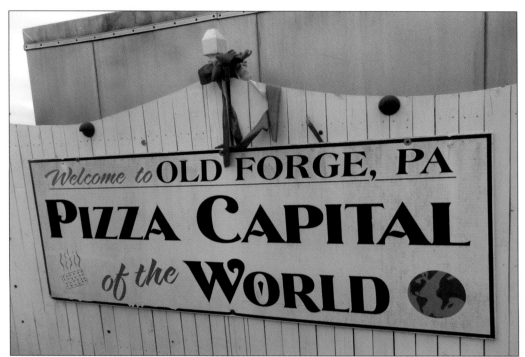

Many pizzerias in the region make their pizza in the "Old Forge style," as Old Forge is considered the "Pizza Capital of the World." *USA Today* ranked its pizza no. 1 in the United States, and even pizza makers in Naples, Italy, refer to rectangular pizza as "Old Forge style." (Author's collection.)

Old Forge's Revello's Pizza was established in 1967 and has used the same recipes for more than 50 years. It is known as the "official pizza" of the Scranton/Wilkes-Barre RailRiders baseball team. Revello's also has locations at the Marketplace at Steamtown in Scranton and at Mohegan Sun Pocono in neighboring Luzerne County. The restaurant's flagship location on Main Street in Old Forge has been visited by former secretary of state Hillary Rodham Clinton, former Pennsylvania governor John Heinz, and Ozzy Osborne. (Author's collection.)

Arcaro and Genell Restaurant was established in Old Forge in 1962 on the site of the former Laurenzi's Restaurant. Having undergone extensive renovations since opening, the restaurant now boasts a bocce court, as well as a separate take-out building. Here, owner Angelo Genell (second from left) was recognized by (from left to right) Lackawanna County commissioners Jerry Notarianni, Laureen Cummings, and Patrick M. O'Malley as part of the board of commissioners' Small Business Spotlight. (Courtesy of Lackawanna County.)

The descendants of Louisa Laurenzi, through her daughter Mary and son-in-law John Rinaldi, opened Café Rinaldi on Old Forge's Main Street. According to Rinaldi family history, Louisa and her friends were among the first women in Old Forge to make the now famous Old Forge–style pizza. The Rinaldi family opened Café Rinaldi and expanded on the family's recipes, offering not only pizza but also Italian specialty dishes, such as their house specialty shrimp risotto. (Courtesy of Russell Rinaldi.)

Founded in Dunmore in 2006 by Larry Nicolais Jr., Constantino's Catering was originally a professional, off-premise catering company. In the decade since its incorporation, it has become the region's premier catering company, offering a wide array of homemade foods. The company's new event venue in Glenburn Township opened in 2017. (Courtesy of Constantino's Catering.)

Constantino's Catering's new event venue is located at the former site of Patsel's Restaurant. When the company took ownership of the building, it completely renovated the interior and exterior to make it into a full event experience for customers. The venue seats 200 guests indoors, 100 guests al fresco, and 300 guests for indoor and outdoor cocktail-style dining. (Courtesy of Constantino's Catering.)

The Genetti family has been in hospitality for four generations, beginning when Damiano Genetti left his home in the Italian Alps to settle in northeastern Pennsylvania. Genetti Manor in Dickson City has been recognized nationally for its dedication to detail for a wide variety of events, including weddings and conferences. The other Genetti family properties are located in Wilkes-Barre, Luzerne County, and Williamsport, Lycoming County. (Author's collection.)

Fiorelli Banquet and Conference Center in Peckville is one of the region's newest facilities for weddings as well as social and corporate events. Having opened in November 2008, Fiorelli Catering has already been recognized as one of the region's premier event venues, garnering awards from regional and statewide publications. (Courtesy of Fiorelli Banquet and Conference Center.)

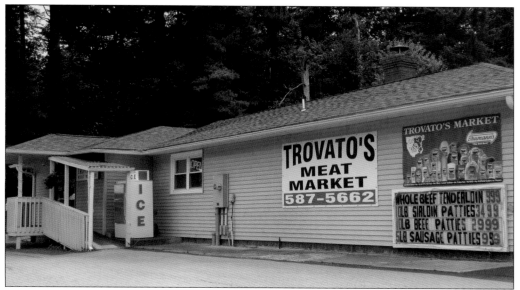

The Trovato family has been in the meat business locally since the 1920s with stores located along Lackawanna Trail in the Abington region of Lackawanna County. In 2000, cousins Carmen and Al Trovato moved the butcher shop into a converted house in Clarks Summit. Longtime employee Brian Schirg purchased the shop in the spring of 2017 when Al Trovato left the business to focus on running OK Beerman in Scranton. Carmen Trovato was seeking to reduce his workload and still remains active with the shop. (Author's collection.)

Clarks Summit–based Caravia Fresh Foods opened in 2004, after owner Joe Cognetti sold his wholesale produce business. Joe, his son, Ryan, and cousins Peter and Marianne were looking to build on their tradition of large family meals with plenty of fresh Italian dishes, and also wanted to bring the burgeoning trend of organic, locally sourced food to their community. They named their concept Caravia Fresh Foods, honoring their Italian heritage through Joseph's grandmother Michelena Caravia, from San Mango d'Aquino. (Courtesy of the Cognetti family.)

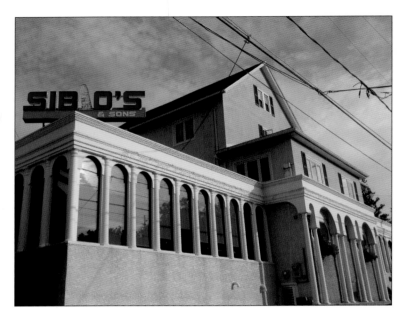

Sibio's Restaurant in Dunmore was established in 1974 by Albert and Bernadine Sibio and is still housed in its original location. Known for its world-class cuisine, Sibio's features dishes created by the Sibio children through their training at the Culinary Institute of America. Chef Mark Hrebin has worked alongside the Sibio family since 1977. (Author's collection.)

The Azzarelli family of Scranton began sharing local history a decade ago with the original play *1877, Riot on Lackawanna Avenue*. Several books and plays later, the Azzarellis can be found volunteering their time at the Lackawanna Historical Society, Anthracite Heritage Museum, or Diva Theater. Their mission is to bring history alive through the arts. Pictured are, from left to right, Marnie Azzarelli, Margo Azzarelli, Dominick Azzarelli, and Jennifer Ochman. (Courtesy of the Azzarelli family.)

Fr. Joseph Sica is a native of the Bunker Hill section of Scranton and has served the Diocese of Scranton in various pastoral ministries, including parish ministry, teaching, and hospital chaplain. He is the author of two books—*Embracing Change: 10 Ways to Grow Spiritually and Emotionally* and *Forgiveness: One Step at a Time*. He is currently the senior priest at Scranton's Immaculate Conception Parish. (Courtesy of Fr. Joseph Sica.)

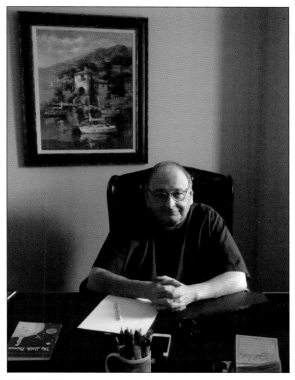

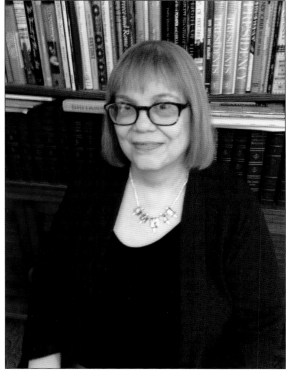

Lee Sebastiani of Eynon is the founder of Avventura Press, which specializes in publishing regional authors, including Italian American writers such as Jerry Fagnani and John Lemoncelli. She says that her Italian heritage means everything to her as her ancestors hail from Gubbio. Per her family history, her most famous ancestor is Bishop Giuseppe Sebastiani (1620–1689), a Carmelite monk sent to India by Pope Alexander VII to reconcile the native Catholics and Jesuits, who were feuding. *Avventura* is the Italian word for "adventure." (Courtesy of Lee Sebastiani.)

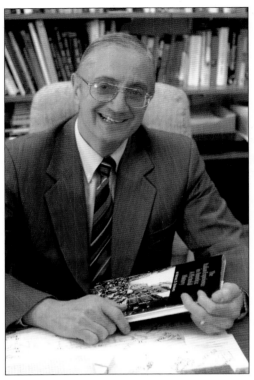

University of Scranton history department professor Michael D. DeMichele, PhD, is the author of *The Italian Experience in America: A Pictorial History*. He joined the staff of the University of Scranton in 1967 and has served as department chair for the History and Political Science Departments, and as faculty adviser for the International Studies program. During his career, DeMichele has received many awards for his teaching and is listed in a wide variety of academic journals. (Courtesy of Dr. Michael D. DeMichele.)

Dr. Roy Domenico received his doctorate in history at Rutgers University in 1987. He has taught at the University of Scranton since 1997 and served as chair of its History Department from 2009 until 2014. Since 2012, he has served as executive secretary of the Society for Italian Historical Studies. Domenico has published a number of books and articles on Italian history subjects, one of which, *Italian Fascists on Trial, 1943–1948*, won the Marraro Prize and was translated into Italian as *Processi ai fascisti*. (Courtesy of Dr. Roy Domenico.)

Daniel and Ferdinand Pesavento, stone carvers from the town of Asiago, Italy, started Pesavento Monuments in Scranton's South Side in 1907. Ferdinand Pesavento opened a second location on Oram Street in Scranton, directly outside the gates of Cathedral Cemetery, in 1912 (pictured). John E. Pesavento is the fourth generation of the family to own the business and recently purchased the original South Scranton location, reuniting it to the Pesavento family, as well as an additional location in Tunkhannock, Wyoming County. (Author's collection.)

John E. Pesavento learned carving from his father, Jack, as well as through formal schooling. He began working in the family business at age 12 by carving letters, names, and dates into monuments while Jack drove him through the cemetery. By the time he was 14 years old, John had begun to draw his own designs. Today, Pesavento Monuments provides lawn-level markers and upright monuments, as well as mausoleums, and can duplicate any existing memorial. (Author's collection.)

Carbondale native John Baldino is a third-generation Italian American who owns and operates Baldino Digital, a regional marketing company dedicated to helping promote small businesses. Prior to opening his business, he worked for major national media companies including the New York Times Company and Nexstar Broadcasting Group, as well as various regional outlets. (Courtesy of John Baldino.)

Samantha Nardelli is a designer and creator from Olyphant. Her design company, Shanty Town Design, works with creative entrepreneurs on visual marketing, including branding, print design, and web design. She also carries a product line of illustrated vinyl decals sold online and at indie craft markets. Nardelli attended Marywood University and has a bachelor of fine arts in graphic design. (Courtesy of Samantha Nardelli.)

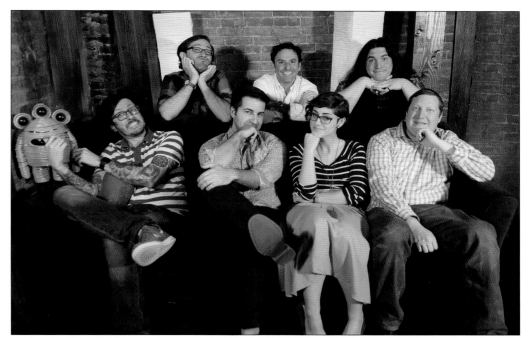

Cofounded by Tony Bartocci, Mat Giordano, and Robert Jones, Scranton-based Posture Interactive is an award-winning interactive agency focused on creating digital products and marketing essentials that help businesses and their brands move forward. (Courtesy of Posture Interactive.)

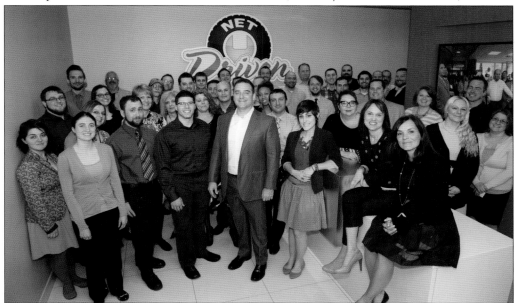

Founded in 2007 by Pat Sandone, a third-generation independent tire dealer, Scranton's Net Driven was born when his family business, Sandone Tire and Car Care Centers, was looking for a solution that would give it proven visibility online. Net Driven helps automotive businesses thrive online by providing powerful-yet-affordable Internet marketing solutions. (Courtesy of Pat Sandone.)

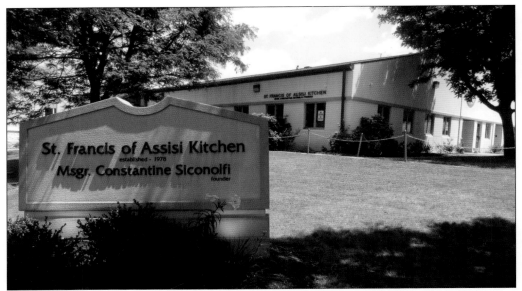

The St. Francis of Assisi Soup Kitchen in Scranton was established in 1978 by founder Monsignor Constantine Siconolfi. In the Catholic tradition and the spirit of its patron, St. Francis of Assisi, the hungry are fed in collaboration with volunteers and donors from all faith communities. The kitchen provides a free, hot, nutritious meal to guests every day of the year. The kitchen also operates a food pantry and a free-clothing store. (Author's collection.)

The families of Mario Mariani and Franco Lorenzetti gather at Franco's house in Jessup. Both men are heavily involved with the St. Ubaldo Society and "La Corsa dei Ceri," each admitting that he is so proud of the tradition that he will carry it on until the day he dies. Franco is a member of the Family of St. Anthony and Mario is a member of the Family of St. George. Pictured are, from left to right, Corinne Sebastianelli, Jean Lorenzetti, Franco Lorenzetti, Mario Mariani, and Blakely Borough mayor Jeanette Acciare-Mariani. (Courtesy of Jennifer Headley Ritzco.)

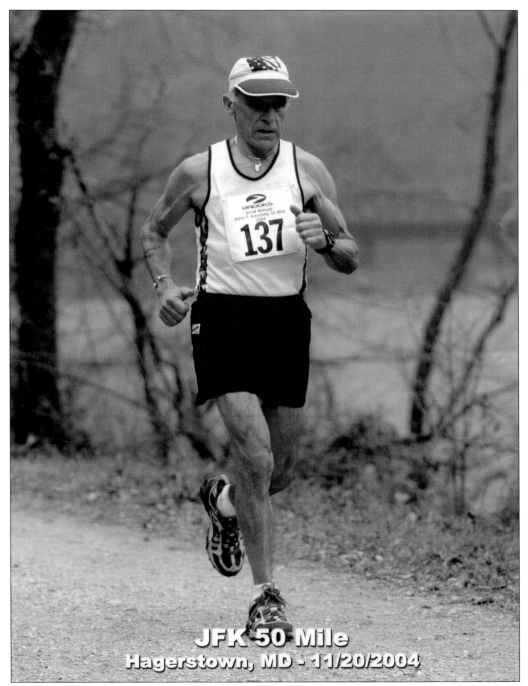

JFK 50 Mile
Hagerstown, MD - 11/20/2004

Eighty-one-year-old Tony Cerminaro of Jermyn began his running career at the age of 47. He now holds the national record for his age group in the Steamtown Marathon and has participated in that race every year since its inception. Cerminaro has also won four first-place awards for his age group in the Boston Marathon and broke a record for his age group in the JFK 50 Mile, where he was the oldest person to ever run the race. (Courtesy of Tony Cerminaro.)

DISCOVER THOUSANDS OF LOCAL HISTORY BOOKS
FEATURING MILLIONS OF VINTAGE IMAGES

Arcadia Publishing, the leading local history publisher in the United States, is committed to making history accessible and meaningful through publishing books that celebrate and preserve the heritage of America's people and places.

Find more books like this at
www.arcadiapublishing.com

Search for your hometown history, your old stomping grounds, and even your favorite sports team.

Consistent with our mission to preserve history on a local level, this book was printed in South Carolina on American-made paper and manufactured entirely in the United States. Products carrying the accredited Forest Stewardship Council (FSC) label are printed on 100 percent FSC-certified paper.

MADE IN THE